THE
BOTANICAL ARTIST

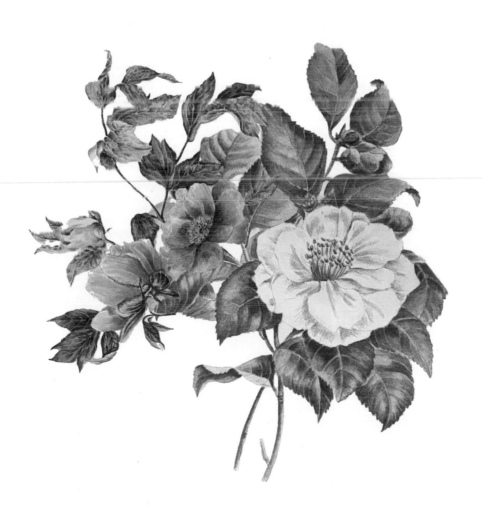

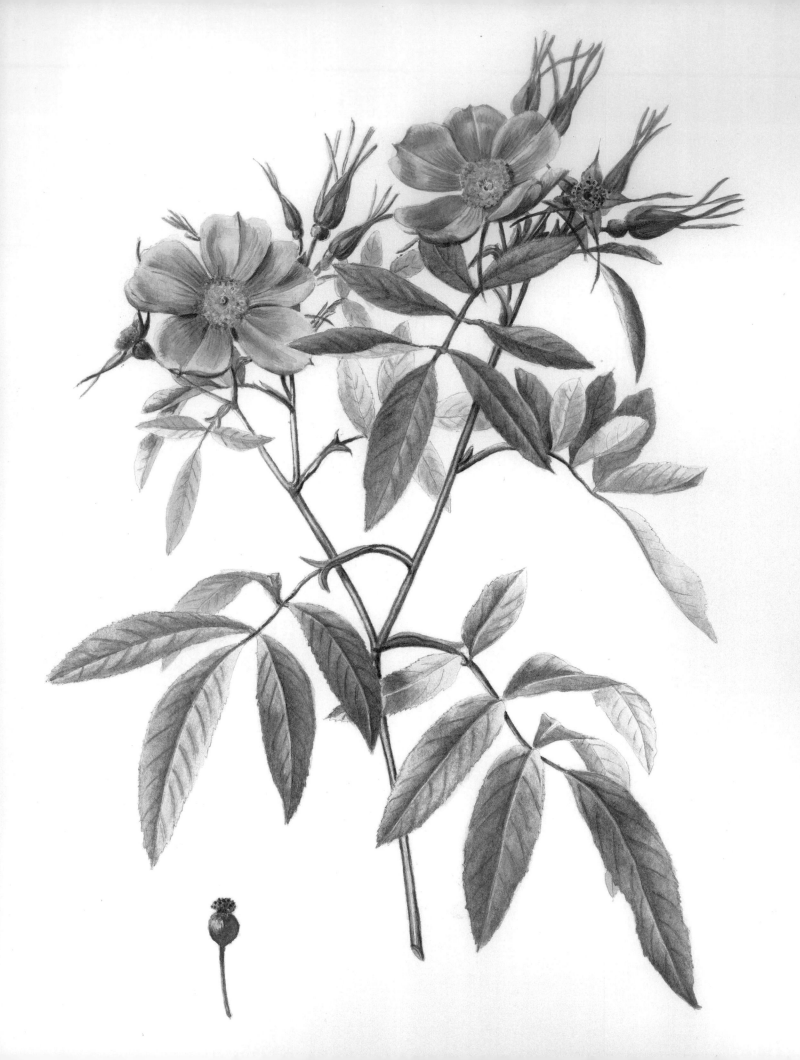

Royal Botanic Gardens **Kew**

THE

BOTANICAL ARTIST

Learn to draw and paint flowers in the style of Pierre-Joseph Redouté

Françoise Balsan

SIRIUS

'He consequently bestowed upon them an unexpected immortality, emanating from those clean, firm and velvety tones for which he held the secret shared only with Nature.'

Jules Janin,

Oraison Funèbre (Funeral Eulogy), 1840

PICTURE CREDITS

SIRIUS

This edition published in 2023 by Sirius Publishing, a division of
Arcturus Publishing Limited,
26/27 Bickels Yard, 151–153 Bermondsey Street,
London SE1 3HA

Based on the original title: *Peindre les fleurs a la manière de Pierre-Joseph Redouté*
Copyright © Arcturus Holdings Limited/Françoise Balsan
English translation by Susan Ries with additional translations by Vanessa Daubney
Original design: Marie Balsan

ISBN: 978-1-83940-680-5
AD006644UK

Printed in China

— CONTENTS —

The instructions offered in this book form a method that is based on the use of watercolour to paint flowers which Pierre-Joseph Redouté practised with such amazing success. He learned the fundamentals of botanical art while working with Gerard van Spaendonck at the Jardin du Roy in Paris, and later perfected his particular style. The method outlined in the following chapters explains how you can produce botanical artworks of great freshness and render the delicacy and details of the flowers.

Redouté never wrote about his technique, but he gave lessons and ran a large workshop. One of his students, Antoine Pascal, revealed the extent of Redouté's unparalleled expertise and his particular use of watercolour. And it was after reading Pascal's book and studying the works of Redouté that I attempted to adapt the method to our modern techniques.

Learning this way of painting from step-by-step lessons should help you produce the most beautiful studies of flowers and plants. In addition, at the end of the book, you will find line drawings of flowers that you can trace, plus advice on the composition of your paintings, the layout of your botanical plates and perspective.

The book is illustrated with examples of Redouté's own work and my personal paintings, all of which I hope will, in turn, inspire your own art.

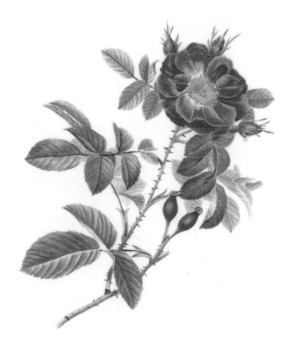

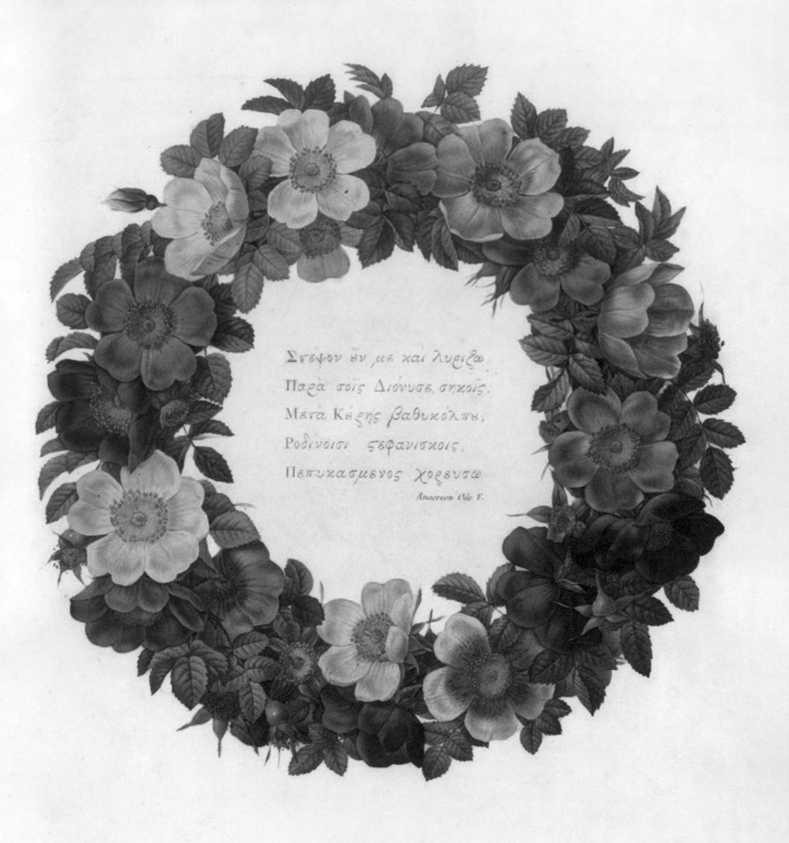

Στέψον ἔν με καὶ λυρίζω
Παρὰ τοῖς Διόνυσε, σηκοῖς,
Μετὰ Κέρης βαθυκόλπε,
Ροδίνοισι ςεφανίσκοις,
Πεπυκασμένος χορευτῷ

Anacreon Ode V.

P. J. Redouté. pinx. Imprimerie de Remond. Clarke sculp.

Pierre-Joseph Redouté, who was born in Belgium in 1759, is the most famous of all botanical painters; his roses, lilies and other flowers decorate innumerable table mats and trays, his paintings are used as pictures and cards around the world. He is rightly famous, because he developed a style which combined botanical accuracy and artistic delicacy and beauty to a remarkable degree. His development of hand-coloured stipple engraving from around 1788 gave his printed work a luminosity which was lacking in the line engraving used until that time for botanical illustration.

Redouté's watercolour technique was equally delicate, and he achieved a feeling of the translucence of the delicate petals of many flowers, but notably of roses. His paintings of roses were inspired and commissioned by the Empress Josephine, wife of Napoleon Bonaparte, whose love of them was famous. It is recorded that in 1810 she obtained a special passport so that rare Chinese roses, including 'Hume's Blush Tea-scented China', could be sent from the Vineyard Nursery in Hammersmith, London, to Paris through the Royal Navy's blockade of France. This legendary rose, now probably extinct, had delicate, very pale, flesh-pink petals and flowered throughout the year; Redouté's lovely painting of it was published in 1817.

Redouté had been in London himself several years previously, in 1786 and 1787, in the company of his early patron, the botanist Charles L'Héritier de Brutelle. They visited Sir Joseph Banks, and Redouté made paintings of rare plants growing in the gardens at Kew and in other collections near London, many of which had recently arrived from the Cape and the Canary Islands. These were used in *Sertum Anglicum* etc., 'An English Wreath, or rare plants which are cultivated in gardens around London, primarily in the Royal Garden at Kew, observed from the year 1786 to the year 1787'. They were published as engravings which could be hand-coloured, and the delicacy of Redouté's handling of many plants can be seen in this early work.

Kew's connection with botanical art as well as horticulture dates from around this time. In the

Above: Strelitzia reginae by Franz Bauer.

Opposite: A garland of roses by Pierre-Joseph Redouté.

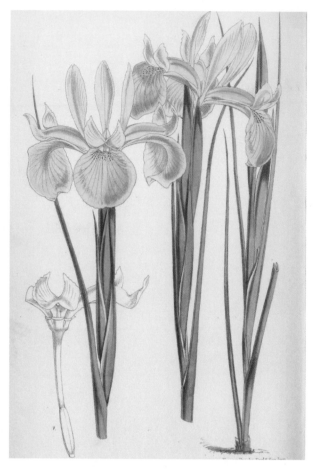

absence of photography, a painting was the only way to record the first flowering of a rare plant in the garden, and artists were employed for this purpose. The most famous botanical artist associated with Kew was Francis Bauer, brother of the even more famous Ferdinand who was artist on the Mathew Flinders expedition to Australia in 1801–03. Francis remained in Kew, painting the rare plants that flowered in the garden and doing early microscope work on orchids and their minute seeds, as well as a fine collection of heathers from the Cape, then the height of fashion. Sadly, Francis Bauer's original paintings are now in the Natural History Museum, as conditions then at Kew were considered inadequate to house them!

The historic botanical paintings collection in the library at Kew is now probably the largest in the world. The credit for this belongs mainly to Sir William and Sir Joseph Hooker, who were directors from 1841 to 1885, and their successors. Sir William brought with him from Glasgow all the early paintings for *Curtis's Botanical Magazine*, a quarterly journal still published today, as well as a most accomplished artist, W. H. Fitch, who recorded new plants flowering in the garden. Sir Joseph collected large numbers of paintings from China and India to use for his *Flora of British India*, as a backup for the dried plant specimens in the herbarium; the Indian collection was hugely augmented by paintings from the India office and private collectors, made by Indian artists for Scottish doctors and botanists working in India. They are now one of the highlights

Above left: Iris juncea by W. H. Fitch.

Below left: Nelumbium speciosum from the Roxburgh Collection at the Royal Botanic Gardens, Kew.

of Kew's collection, combining Indian aesthetics with western scientific illustration. Another highlight is a small collection of pencil drawings by Redouté himself and his contemporary Pancrace Bessa of leaves of North American oaks, possibly intended for *The North America Sylva* by F. A. Michaux published in 1818–19.

Kew's collection is not all historic, however, and new paintings are continually being added by a team of dedicated botanical artists, both painting in watercolour and making pen and ink scientific drawings. Christabel King, Andrew Brown, Joanna Langhorne, Lucy Smith and Deborah Lambkin all work for Kew's scientists, illustrating new or rare plants for publication and for the library's collection.

Dr Martyn Rix
Editor, *Curtis's Botanical Magazine*
Royal Botanic Gardens, Kew

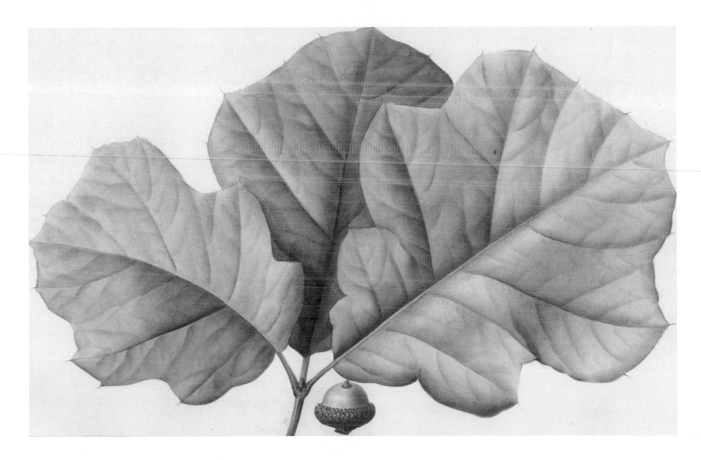

Above: Quercus rubra by Pierre-Joseph Redouté.

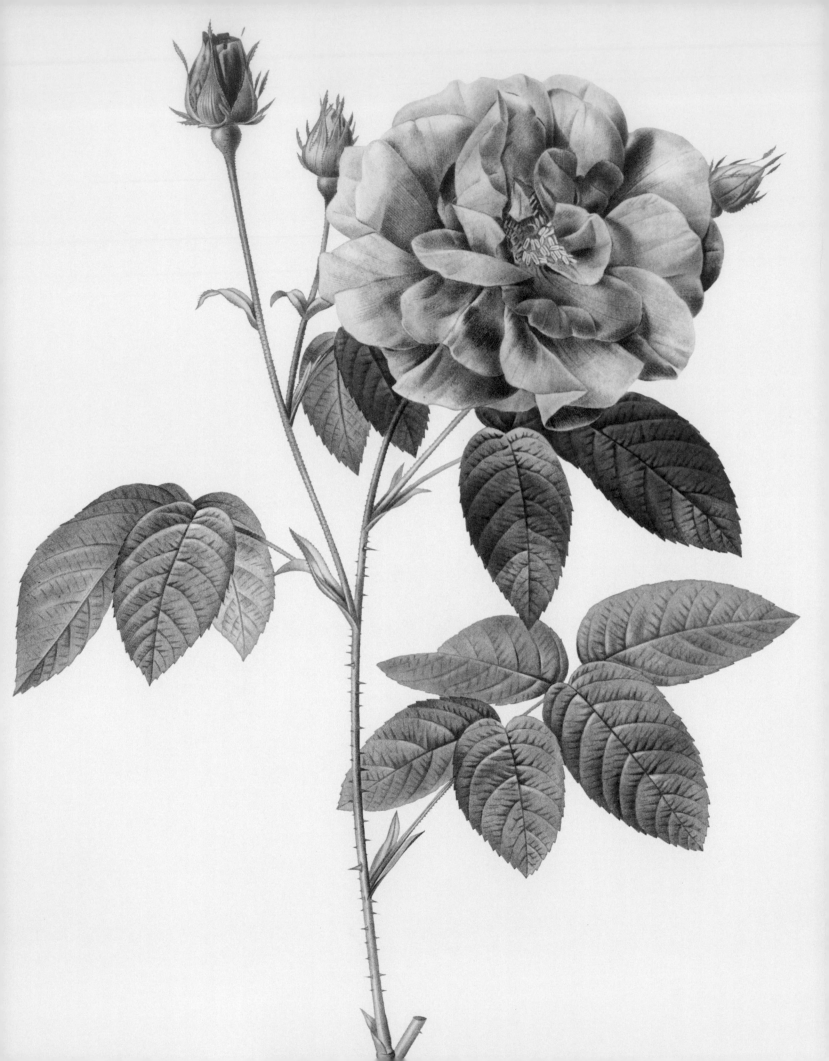

CHAPTER 1

THE LIFE OF PIERRE-JOSEPH REDOUTÉ
AND AN INTRODUCTION TO HIS TECHNIQUE

— PIERRE-JOSEPH REDOUTÉ —

(1759–1840)

Pierre-Joseph Redouté was born in Saint Hubert in the Belgian Ardennes into a family of painters. His older brother, Antoine-Ferdinand, moved to Paris to work as an interior decorator and scenery painter. It was during a trip to Flanders that the young Pierre-Joseph was deeply impressed by the works of Jacobus van Huysum (1687–1740), a master of flower painting and he subsequently travelled to Paris to become his brother's assistant. What he enjoyed above all, however, was creating the flowers that he painted patiently and with great care in the Jardin du Roi, the botanical gardens that became known as the Jardin des Plantes after the revolution of 1789.

His career took a decisive turn when he met the botanist Charles Louis L'Héritier de Brutelle, who ordered botanical plates from him to illustrate several scientific works. Pierre-Joseph's younger brother, Henri-Joseph, joined him in Paris and they began painting in close collaboration.

Gérard van Spaendonck (1746–1822), the Master of Drawing at the Jardin du Roi, invited Pierre-Joseph to assist him in his work and charged him with the responsibility for producing numerous illustrations. It was probably during this period that Pierre-Joseph abandoned gouache and switched to watercolour as his preferred medium. Shortly thereafter, Marie-Antoinette appointed Pierre-Joseph Draughtsman of the Queen's Cabinet. Although this was a purely honorary title, it nevertheless allowed him to paint at the Petit Trianon in Versailles.

Pierre-Joseph continued his collaboration with L'Héritier as well as the botanists Étienne Pierre Ventenat, François André Michaux, and Augustin Pyramus de Candolle.

In 1793, he was commissioned to contribute to a series of botanical paintings – the vellums of the National Museum of Natural History in Paris – while Henri-Joseph was commissioned to work on the zoological vellums.

Pierre-Joseph exhibited for the first time at the Salon of 1793, showing an oil painting titled *Corbeille remplie de fleurs sur une table de marbre* (*Basket filled with flowers on a marble table*) as well as some botanical watercolours painted on vellum. In 1796, he exhibited *Un vase de cristal rempli de différentes fleurs posé sur un socle d'albâtre* (*Still Life with Flowers in a Glass Vase*). However, facing stiff competition from prestigious painters such as Jan Frans van Dael (1764–1840), he abandoned oil painting to devote himself mainly to watercolour and botanical painting. Throughout his career, Pierre-Joseph argued that it was better to be a good watercolourist than a bad oil painter.

A prosperous time began for Pierre-Joseph when Empress Joséphine – Napoleon's first wife, and a great fan of botany – became his patron and invited

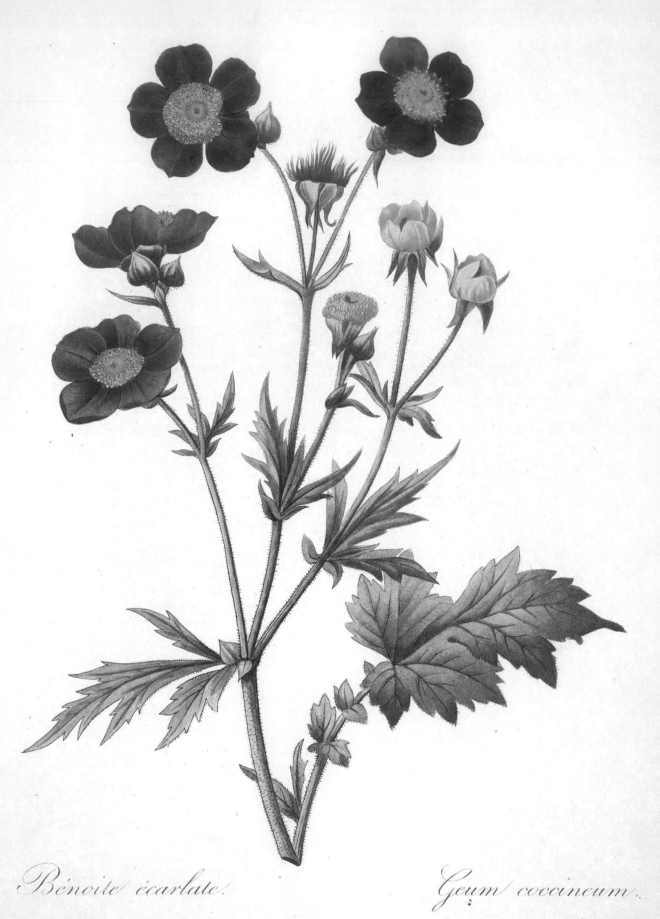

Bénoite écarlate. *Geum coccineum.*

P.J. Redouté. _ 64.　　　　　　　　　　　　　　　Chapuy.

him to work at her chateau in Malmaison. In 1805, he became the master floral painter to the Empress. In the following years he produced his finest works, including the famous *Liliaceae and Description of Rare Plants Cultivated in Malmaison and Navarre*. The Empress even ordered a porcelain table service from the Sèvres factory and named it 'Lillaceae and Malmaison Flowers', based on Redouté's watercolours.

The artist's financial situation improved, allowing him to acquire a beautiful estate in Fleury, near Meudon, where he cultivated rare trees and plants and created a rose garden.

Opposite: Geum coccineum by Pierre-Joseph Redouté.

Below left: Magnolia macrophylla by Pierre-Joseph Redouté.

Above: Redoute's drawing school in Paris.

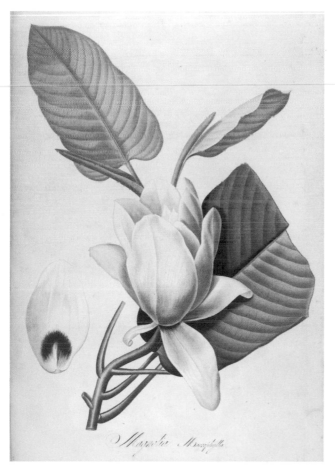

In 1807, Pierre-Joseph opened a Paris workshop at the Mirabeau Hotel on rue de Seine in Saint-Germain. Along with several collaborators, he taught botanical painting every Monday from November to April, becoming a sought-after teacher and drawing master to royal students. He taught watercolour painting to Queen Marie-Amélie, the wife of Louis-Philippe, to Princesses Louise and Marie d'Orléans, and to the Duchess of Berry, who became his patron.

After Joséphine's death, Pierre-Joseph became his own publisher, and released *Les Roses* in 1816. He was also the head of an engraving workshop, which he directed rigorously. The stipple engraving technique – which he learned during his trip to England at the beginning of his career and used extensively in his work – provided great softness in his illustrations.

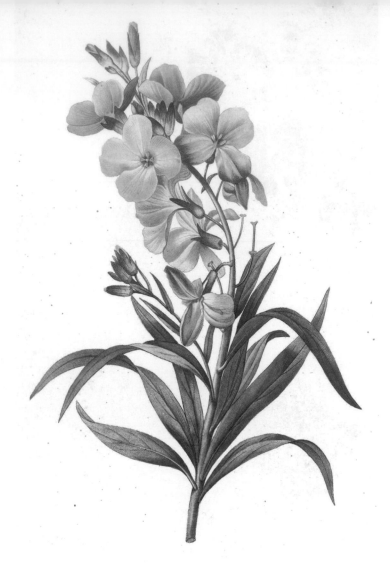

He did not do the engraving himself; that task was performed by craftsmen who worked under his supervision.

In 1822, Redouté was appointed Master of Drawing at the National Museum of Natural History. And it was there that, two years later, he taught his first public painting lesson; it was attended by 120 people. He published *Choix des plus belles fleurs* (*A Selection of the Most Beautiful Flowers*) in 36 instalments in 1827.

Unfortunately, during the period known as the July Monarchy (1830–1848), his paintings went out of fashion. Commissions became rarer and he suffered financial difficulties. In 1840, he died of a stroke while painting.

Above left: Chieranthus flavus by Pierre-Joseph Redouté.

Below left: Primula auricula by Pierre-Joseph Redouté.

Opposite: Bengale Thé hyménéè (White Bengal tea rose) by Pierre-Joseph Redouté.

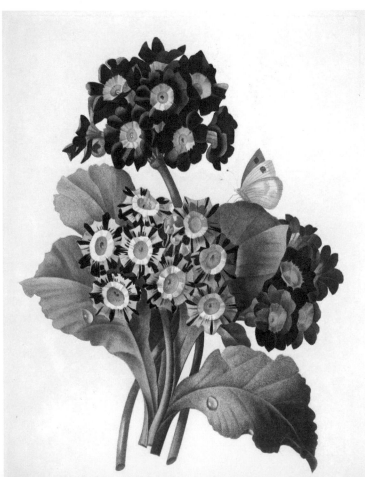

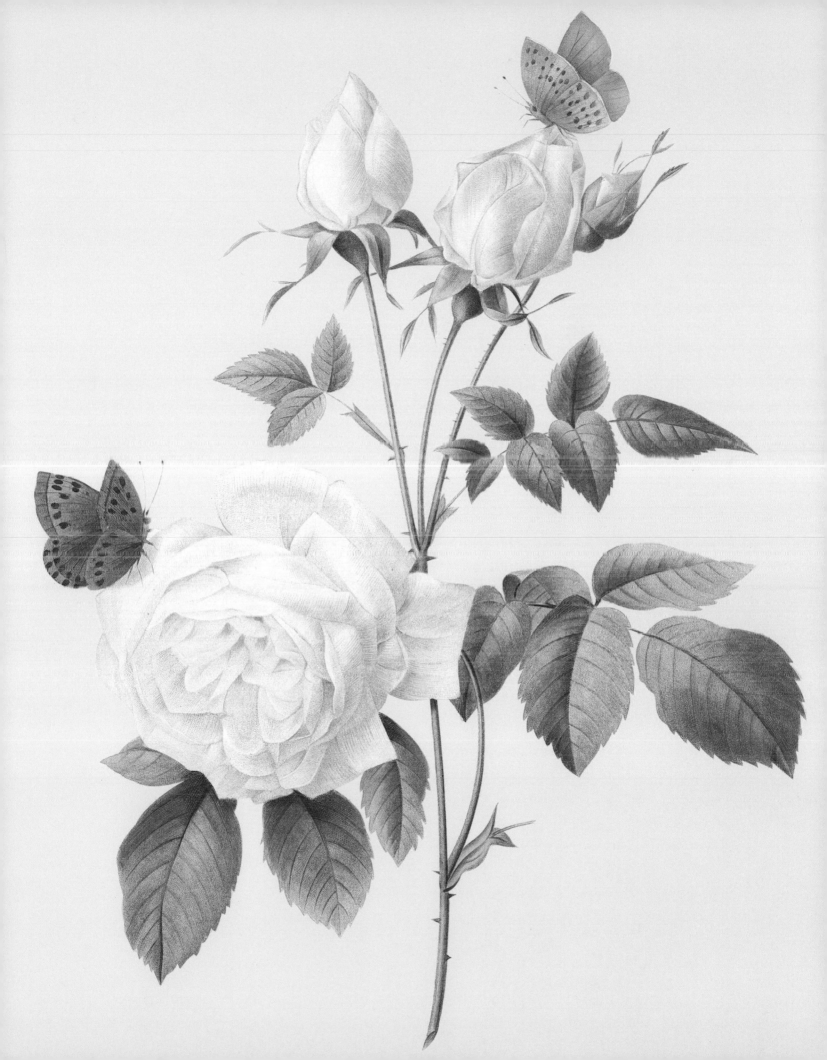

— WHY WATERCOLOUR? —

Pierre-Joseph Redouté chose watercolour as his preferred technique early in his career. He was certainly influenced by Gérard van Spaendonck (1746–1822), a professor of flower painting at the Jardin du Roi and then at the Museum of Natural History. Van Spaendonck was also the King's painter of miniatures, and the first professor of iconography at Paris' Museum of Natural History. In contrast with traditional botanical painters, who often worked with gouache – the colours being more creamy and often mixed with white, resulting in an opaque painting – Redouté painted with subtle glazes: as mentioned in the euology at Redouté's funeral in 1843, 'It was at this point, tired of the thickness and opacity of gouache – whose matte, thick, dull colour fades, deteriorates and flakes easily – Redouté switched to watercolour – so light, so brilliant and so fresh that, under his large and flexible brush, the brilliance, transparency and the delicacy of the flowers whose portraits he painted were realised so well.'

Watercolours can be prepared completely liquid on a palette. The brush is filled with colour, then the artist places the coloured washes on paper or vellum. As recalled by Antoine Pascal, a student of Redouté, 'a lighter shade is not achieved by using less colour but because it will have been prepared as such on the palette.'

The technique developed by Redouté is different from traditional miniature-painting techniques used since the Middle Ages (and still in use by some botanical painters). The older technique consists of using a very fine brush to apply a multitude of small lines or dots that form colour, shadow and detail. It is a long process and was not suited to Redouté, who was trained in oil painting. Using such a laborious method, even with the help and collaboration of his brother, Henri-Joseph, he would not have been able to paint so many botanical plates: more than 1,700 images that were then supposed to be engraved. Redouté needed a technique that allowed him to work quickly. Using watercolour, an innovative approach at the time, he achieved a transparency and a richness of colour that were on a par with his oil paintings.

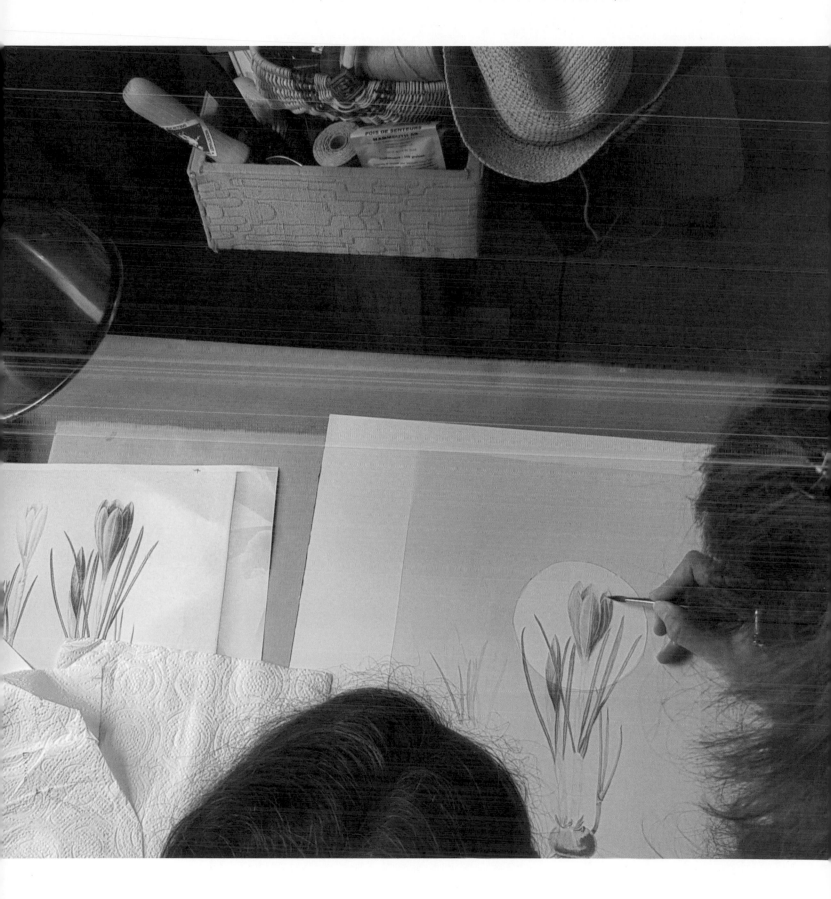

— LEARNING BY COPYING —

Redouté required all his beginner students to learn the basics of drawing, the study of shadow and light and watercolour techniques by copying his engravings or vellums. He said: 'Constantly encouraging the numerous students and teachers who eagerly follow my iconography course, it seemed to me that this learning required new models, models that helped them [the students] avoid common mistakes such as inaccuracy, stiffness and monotony. The models included in this work so faithfully imitate nature that without doubt the pupil who copies them during winter, upon the return of spring, will be able to compare them with the flowers to which it gives birth.'

We will also follow this traditional way of learning, which allows you to progress quickly, step by step. Then, after learning the basics and copying, we will work from nature. Finally, we will discuss painting on vellum in Chapter 15.

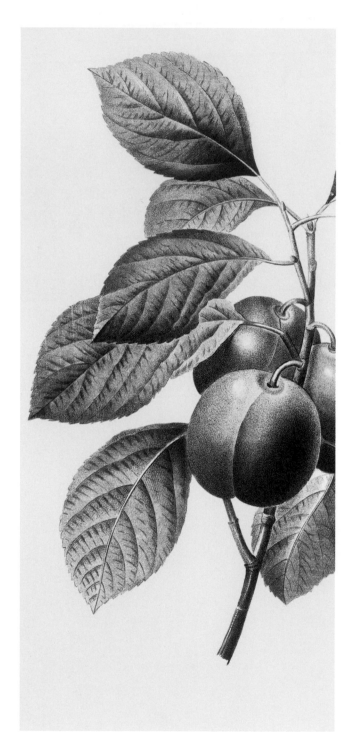

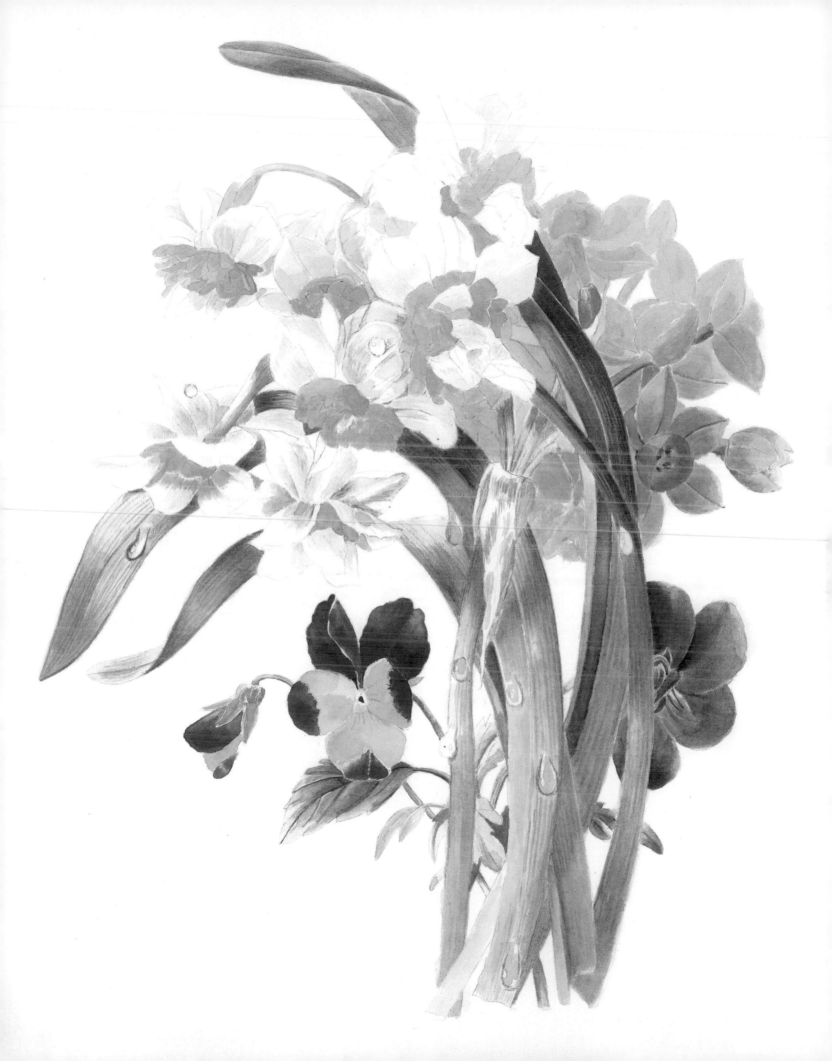

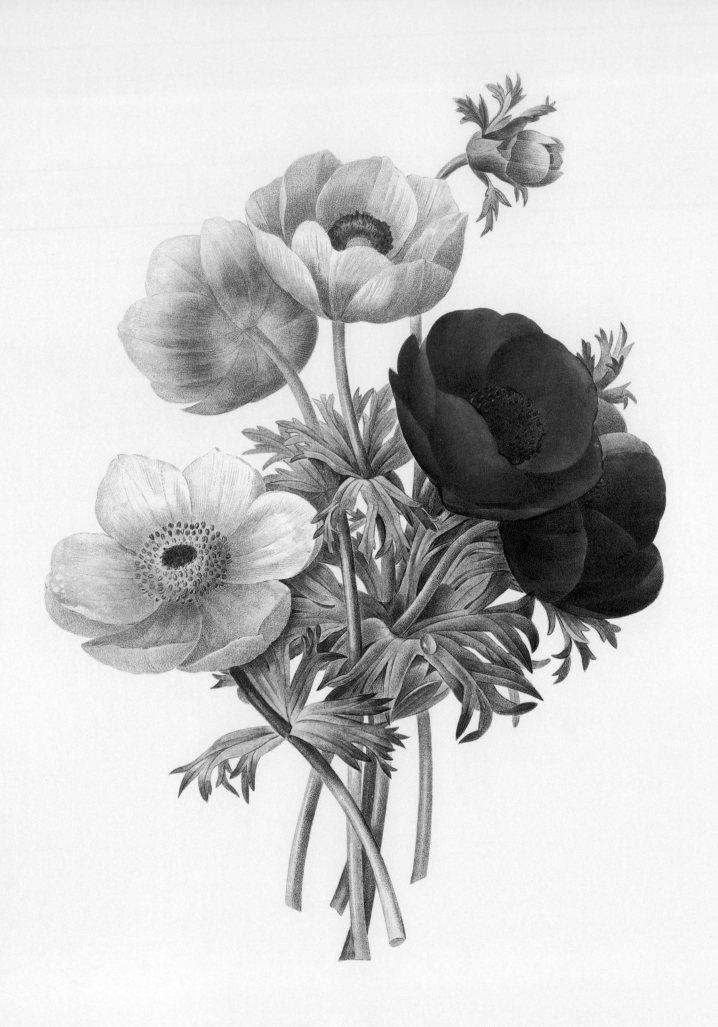

— MATERIALS —

PAPER

Traditionally, flowers were painted on vellum, a high-quality, extremely fine white parchment made from the hide of stillborn calves. Its use dates back to Medieval miniatures. From the 17th century, and the creation of the vellum collection of Gaston d'Orléans, brother of Louis XIII, vellum was considered the superior paper. However, while producing exceptional rendering, vellum presents additional difficulties for beginners. See Chapter 15 for more information on this.

In Redouté's time, paper was stretched over board and dampened before any paint was applied. As a beginner, it is advisable to use good-quality watercolour paper. I use 300gsm Arches Aquarelle Hot Pressed, and it's perfect for botanical paintings. It is sold in blocks or in the French format called 'raisin' (50 x 65cm), which allows you to create custom sizes. Its surface is smooth, without grain, and the paper is almost ivory in colour. For those who prefer loose sheets, the Arches watermark indicates the correct side of the paper to use. Unfortunately, this paper does not like excess water. Alternatively, you can use Fabriano paper, which also gives excellent results.

PALETTE

The ideal palette is made from porcelain or earthenware (a square plate will do just fine). It can also be made of plastic, with a large central area; a plastic lid works well.

BRUSHES

Three brushes are enough, as long as they are chosen with care. They should be densely packed with hair and, after being immersed in water, the tip should be very fine. I use two Kolinsky sable brushes from Raphaël of France: series 8402, a No. 3 and a No. 2, and a shorter sable brush from Isabey-Special 6227, No. 2. However, you can use other brands: Winsor & Newton brushes, for example, are also suitable.

The brushes have three uses: the first brush is for basic painting; the second is for finishing, modelling the flower, and painting the details. The third brush, as it is shorter, is used for details, small strokes and crosshatching like one would with a pencil. In addition, another, larger brush should be used to extract the colour from the pans or tubes and mix it on the palette (however, you can also mix the colours with your finger).

A pipette is useful to add water to the colour, and also to wet it if it dries out and you want to use it again.

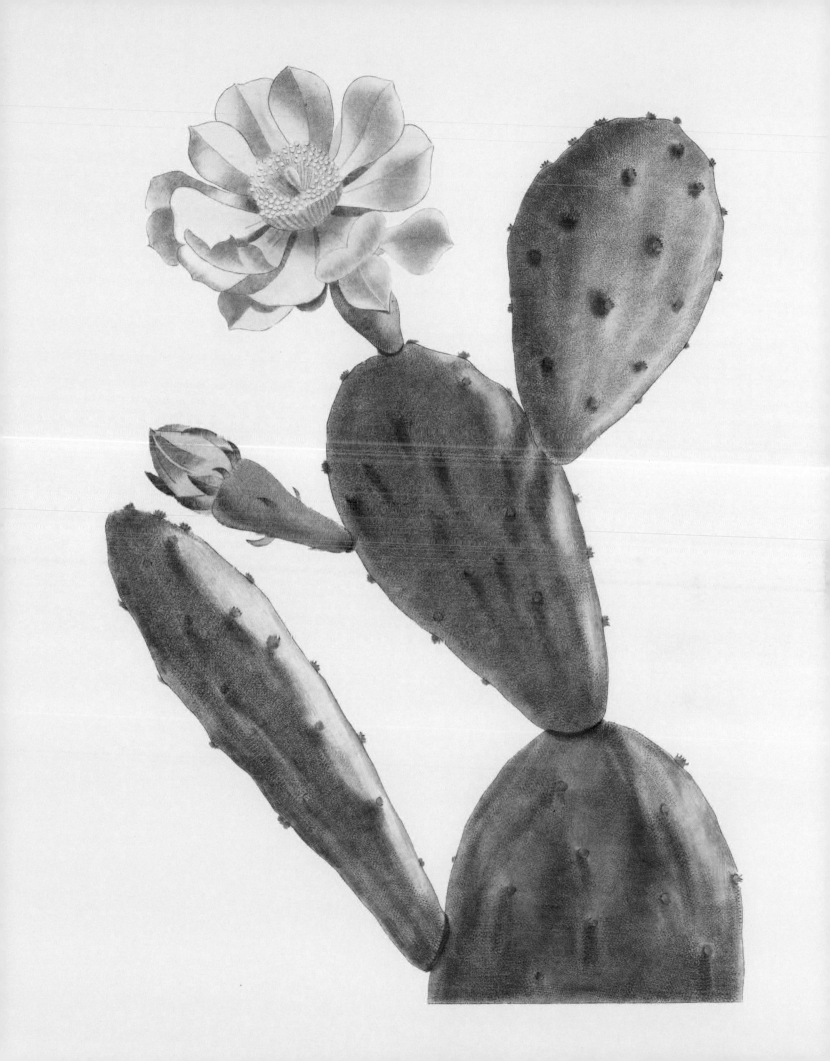

COLOURS

The number of colours used is limited. As Étienne Huard indicates in his book *The Art of Painting Flowers in Watercolour without a Master,* 'It's not the multiplicity of colours that produces a rich palette but rather the art of using a few.'

Watercolours are made from mineral, vegetable and chemical pigments.

The colours used by Redouté were restricted to the essentials:
Yellow: gamboge, Indian yellow, saffron
Red: carmine
Blue: Prussian blue, cobalt, indigo
India ink or a neutral tint of Winsor & Newton

Other colours can be added, particularly earth tones: natural or raw sienna, burnt sienna, sepia as well as white, although it is rarely used. These are natural tones.

BLUES:

a. Indigo is obtained by fermenting the leaves of the indigo plant (*Indigofera tinctoria*). The colour has been used since ancient times and was described in the works of Pliny the Elder. It is a dark shade of blue with intense covering power.

b. Prussian blue is an artificial pigment discovered by chemists in Berlin in the 18th century. It is a strong, cold hue with greenish tones and intense covering power. It is useful for creating green shades.

c. Cobalt is a synthetic mineral pigment discovered by a French chemist in 1802. It is made of cobalt aluminate.

d. Ultramarine is made from a semiprecious stone, lapis lazuli, which is found in Afghanistan. It is a stable pigment when exposed to light.

YELLOWS:

a. Gamboge is a bright yellow with orange overtones. It is made from the resin of the gamboge tree and was known to be toxic. Various watercolour paint suppliers now make a 'new gamboge' that is a fine substitute.

b. Indian yellow was originally produced from the urine of cows that had been fed mango leaves. This method has been prohibited since the 20th century, to protect animals. Today, we use an artificially manufactured pigment that is warm and bright, and useful in painting yellow flowers.

c. Saffron is obtained from the pistil of the *Crocus sativus* flower. This paint must be prepared and stored in a plastic or glass jar (*see* Chapter 18). Saffron is often mixed with carmine to obtain vermilion.

REDS:

a. Vermilion is a bright red hue formerly made from highly toxic mercury sulphide; it has been replaced by cadmium red.

b. Carmine is obtained from the cochineal, an insect that is native to North America and South America. In Redouté's time, it was powdered and mixed with liquid ammonia.

(a) (b)

EARTH TONES:

a. Natural or raw sienna is an iron oxide containing alumina; it is a transparent brown.

b. Burnt sienna is a warm brown that is used infrequently.

(a)

(b)

In addition, we use sepia, a purplish brown obtained from squid ink, and Winsor & Newton's neutral tint. India ink is difficult to use as it dries very quickly on the palette and mixes poorly with other colours. Winsor & Newton's neutral tint is a good replacement, and in the following chapters we will refer only to this tint even though India ink was used in Redouté's time.

White gouache is used rarely (usually when the white of the paper has been lost). But it should not be excluded under the pretext of orthodoxy. Nineteenth-century artists used it freely; for example, you can see its use in J.M.W. Turner's watercolours. Redouté often resorted to gouache.

Secondary or compound colours, such as purple, (a mixture of carmine and blue) are obtained from two or more colours. A *teinte brisée* is a natural or compound colour to which another colour is added that transforms it without changing it entirely. For example, a green obtained by blending yellow and blue is considered too raw, so another colour – often an earth tone such as burnt sienna, sepia or even black – is added to transform the green without changing it completely.

You can prepare colours yourself using pigments. At the beginning of the 19th century, colours were prepared in tablet or block form, except for saffron (*see* recipes in Chapter 18).

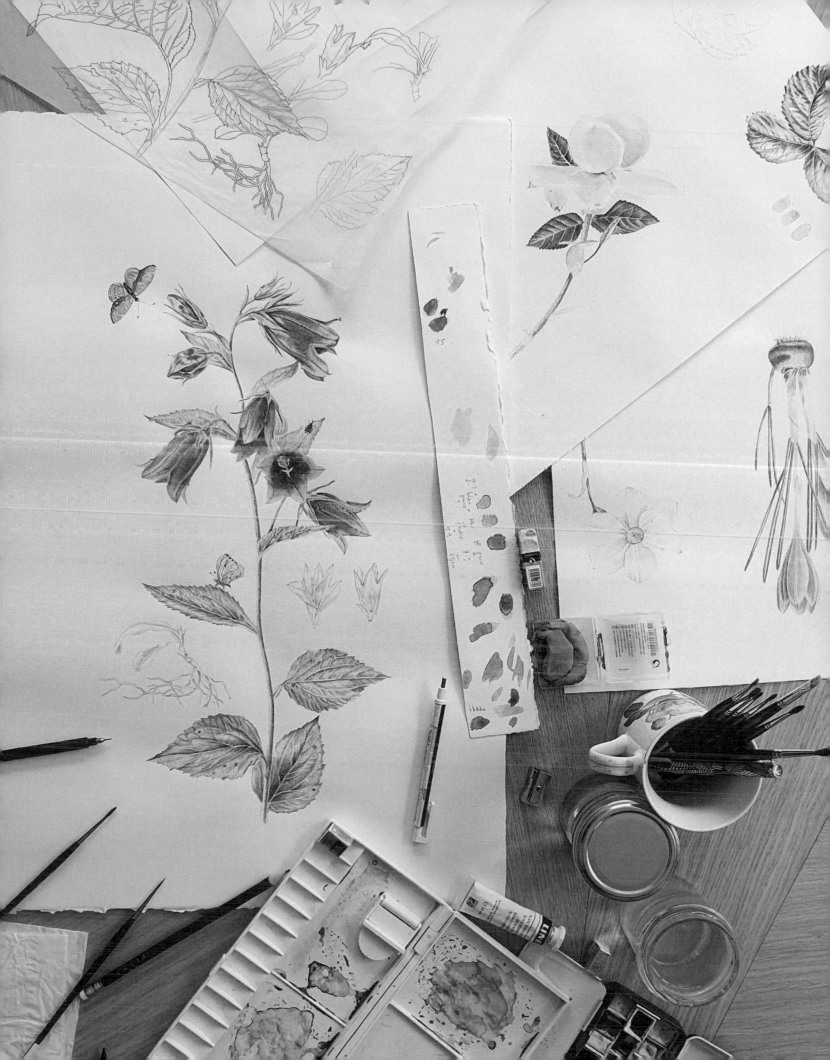

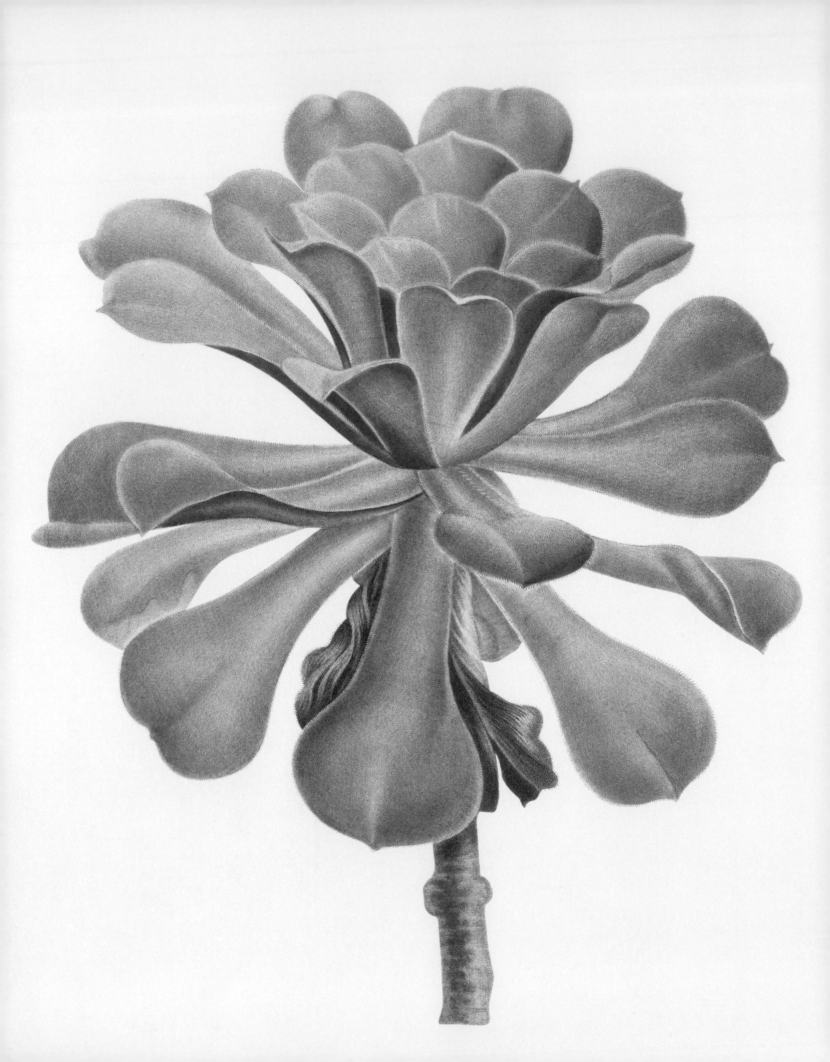

CHAPTER 2

TECHNIQUES

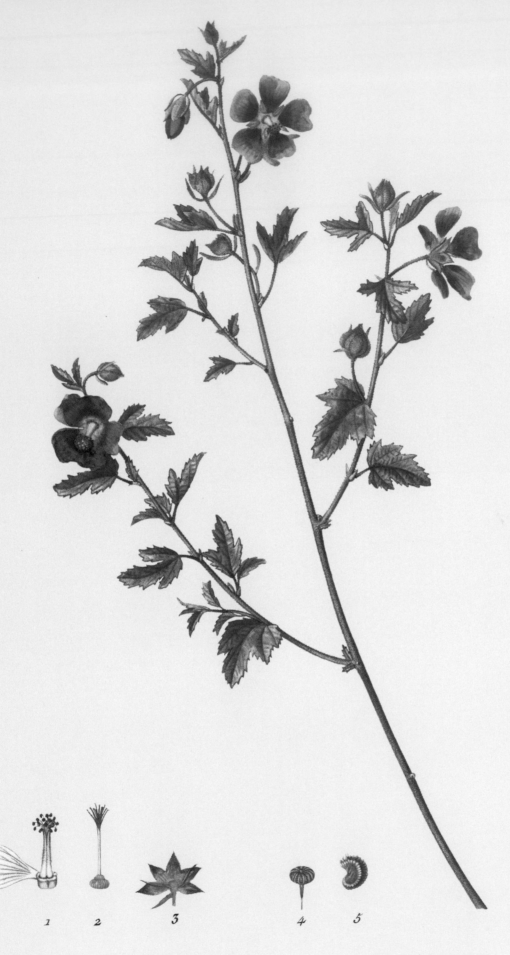

1 2 3 4 5

MALVA virgata. MAUVE effilée.

P Bessa pinx. Gabriel sculp.

— DRAWING FLOWERS —

Let's start with fairly simple flowers such as tulips, periwinkles and rosebuds.

I recommend first drawing the flower on drawing paper and then transferring it onto the watercolour paper with tracing paper. But be careful: the paper is fragile; beginners tend to add too many details and force the lines, which can leave unsightly marks on the finished watercolour.

Two pencils are used: a hard one (H/#2) and a softer one (B/#1).

1. The soft pencil is used to draw the general shape and outline of the flowers. The outline should be simplified: a circle or ellipse.

2. Draw the main petal and gradually add the others. Trace the stem with a line, being careful to capture its movement.

3. For the leaves, start by drawing the general shape and then add the main veins. At this stage, it's not necessary to add detail. The first lines do not need to be exact. It's preferable not to erase; instead, refine the drawing as you progress. Check that the proportions are correct.

4. The next step is to gradually add detail with the hard pencil, with the first line serving as a guide. Modify the drawing, if necessary, as you carry on. Take a step back to observe the drawing from a distance, to check that it is correct. Then add the interior details of each petal or flower. Begin modelling the flower by adding light crosshatching to indicate shadows and capture the movement of each part.

5. Once the drawing is finished, use a kneadable putty eraser to remove the initial soft pencil lines. Then, using tracing paper, transfer the drawing onto the watercolour paper.

— THE WATERCOLOUR SKETCH —

The basis of Pierre-Joseph Redouté's technique is called *ébauche*, which roughly translates to 'sketch'. This method, although a little delicate to begin with, consists of making large quantities of three or four tones of the same colour on the palette, and applying them directly to the prepared drawing, thereby simultaneously achieving light, half-tones and shadows with speed and fluidity.

This painting technique, like all watercolour work, is done on a support (a board, for example) tilted at about 30° so the colour can flow slightly downwards.

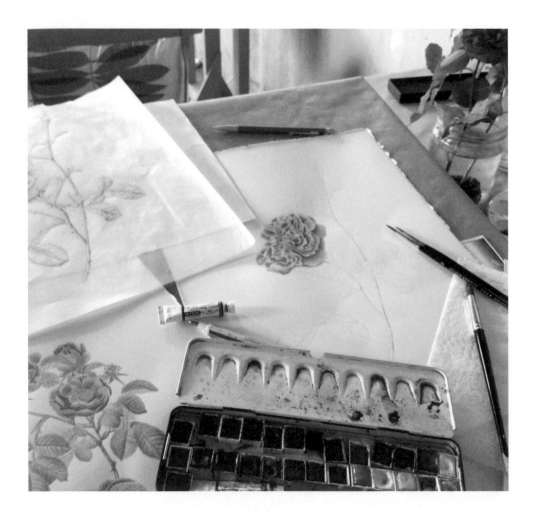

— COLOUR TONE RANGES —

FOUR-SHADE PALETTE

The first step toward understanding Redouté's technique is to create a range of tones on the palette – four shades of the same colour. Begin by preparing a very light shade containing little pigment. The second shade should contain more pigment, and so on. Gradually increase the intensity of the colour until you have four shades. These colours will contain a lot of water, but not too much, and you will prepare them in fairly large quantities.

CREATE A COLOUR TONE BAND

Using a No. 3 Raphaël brush (or similar) filled with paint, apply the palest shade by dragging the brush from left to right. Then carry on, gradually intensifying the colour. Each shade should be applied at the outside edge of the previous one, so the colours flow together smoothly. (To facilitate the layout of this book, the example is presented horizontally, whereas in practice the tone ranges are usually executed vertically.)

COLOUR TONE BAND AFTER DRYING

If the first tone is barely visible, lay a water glaze (i.e. water only) and then gradually add a small quantity of the other shades on top of it.

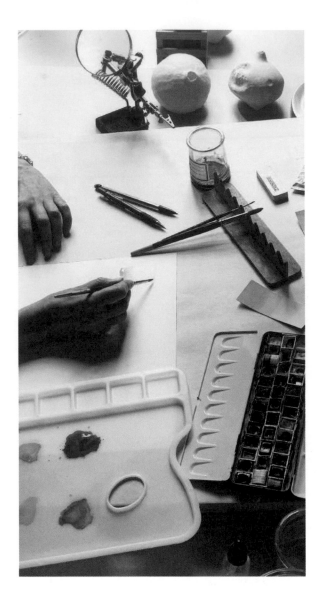

It's important to remember that the brush serves only to guide the colour as it intensifies from tone to tone. Be careful not to wait until the brush runs out of colour to move on to the next tone. And finally, try not to rub the brush too much. When you move on to each new tone, wipe off the brush; it is not necessary to absorb more water, because the four shades created on the palette should contain sufficient water.

An excess of water may result in a thin puddle at the lower portion of the tonal band. Absorb it by using a brush that has been dried on a piece of kitchen roll.

Repeat the exercise, creating tonal bands for each of the colours you intend to use in the painting. For light colours, such as yellow, the band may be limited to just three tones.

— FINISHING TOUCHES —

After the watercolour sketch dries, it's time to add finishing touches. Using the finest brush, add small strokes and crosshatching following the direction of the veins, petals, stems, etc. Be careful not to overdo this step; the brush is full of pigment, and too many brushstrokes may remove the underlying colour glazes, especially when painting on vellum (*see* Chapter 15).

Another way to proceed with the finishing touches is to superimpose glazes with a brush containing little pigment. This technique is similar to a method known as *estompage* – stamping, using light brush strokes – which softens the whole. After drying, crosshatching is added to accentuate movement and emphasise shadows and light.

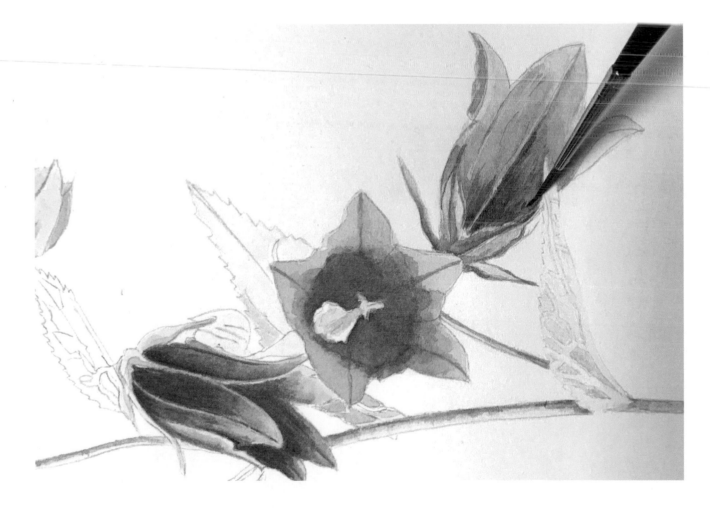

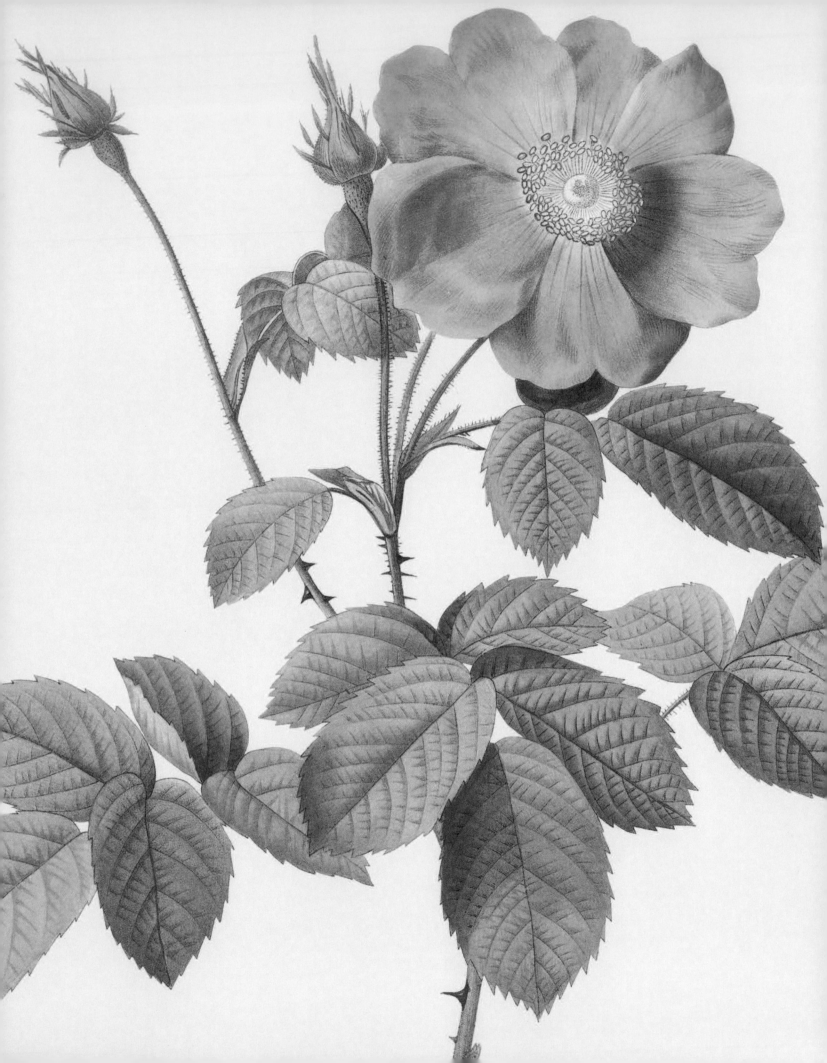

CHAPTER 3

FIRST EXERCISE:
A JAPANESE ANEMONE

— THE DRAWING —

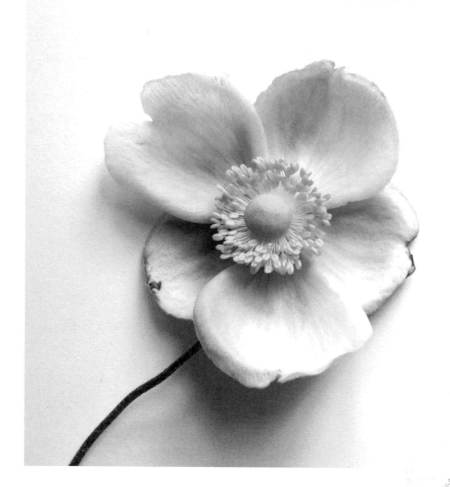

1. Using the soft pencil (B/#1), draw a circle and then add the petals inside it. Place the stamens inside another, smaller circle.

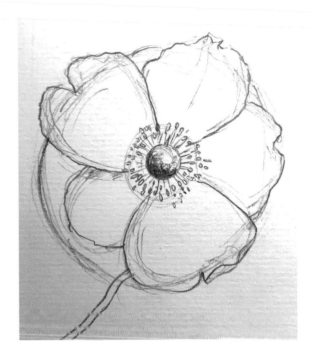

2. Using the hard pencil (H/#2), reinforce the drawing and add details.

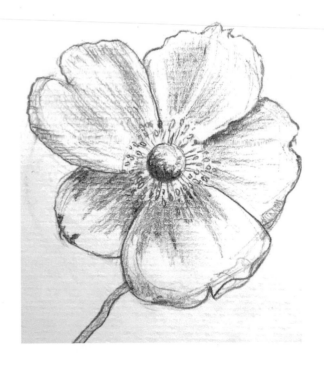

3. Add shadows and erase the construction lines. Use tracing paper to transfer the drawing onto watercolour paper.

Alternatively, use the drawing on page 176. Place tracing paper over the drawing and trace it using a soft pencil. Turn it over, place it on the watercolour paper, and use the hard pencil to go over the drawing, transferring it onto the paper.

— THE WATERCOLOUR —

COLOURS

New gamboge, carmine, Prussian blue, cobalt blue, burnt sienna and sepia.

THE WATERCOLOUR SKETCH

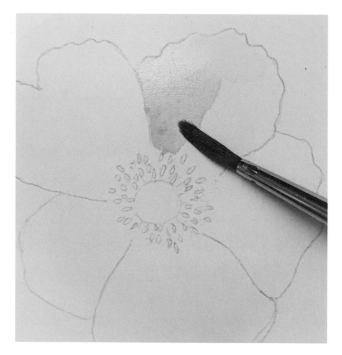

Prepare two shades of carmine: one very diluted, and the other more concentrated. Start painting the petal by applying the lightest shade of carmine, sweeping from edge to centre. In the lightest section of the flower, apply a water glaze followed by the lightest tone of carmine. After the first glaze, add the more concentrated shade as per the specimen shown at the top of page 44. Allow it to dry.

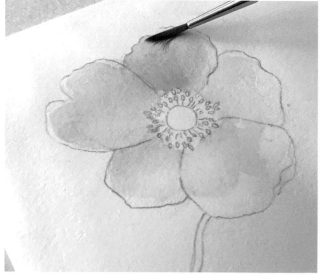

If some of the petals are too light, deepen the colour using the same technique.

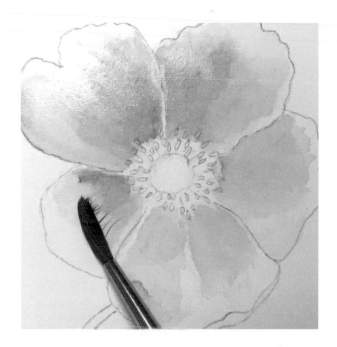

Paint the heart of the flower with new gamboge. Then paint the other petals in the same way.

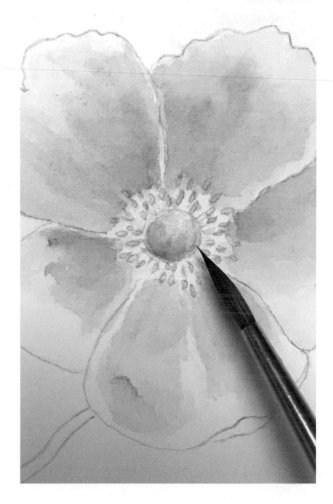

While the yellow centre of the flower is still damp, add a little Prussian blue to form a green hue. Then paint the stamens around the heart with new gamboge.

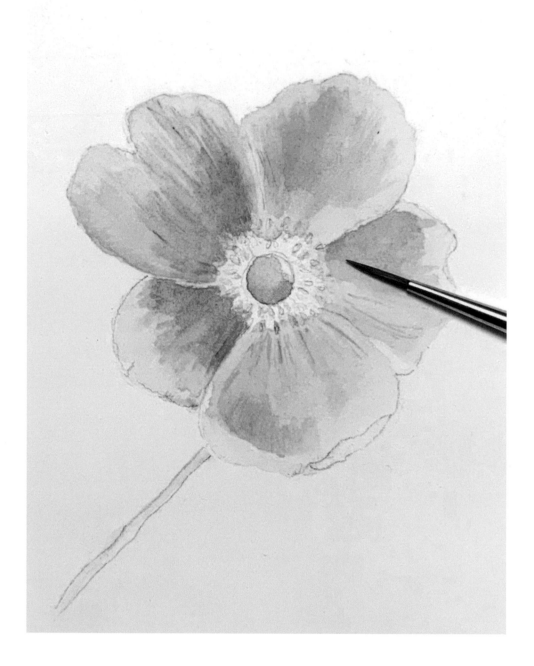

Using a very fine No. 2 brush (such as Isabey special 6227 Kolinsky sable) loaded with concentrated carmine pigment, draw the folds of each petal as well as the shadows to give added dimension to the painting. Paint in small strokes and crosshatching following the direction of the petals, stems and so forth. Erase the pencil lines with a soft putty eraser, avoiding excess rubbing. In the works of Redouté, the pencil crosshatches he made to create shade before starting the painting can often be seen through the watercolour.

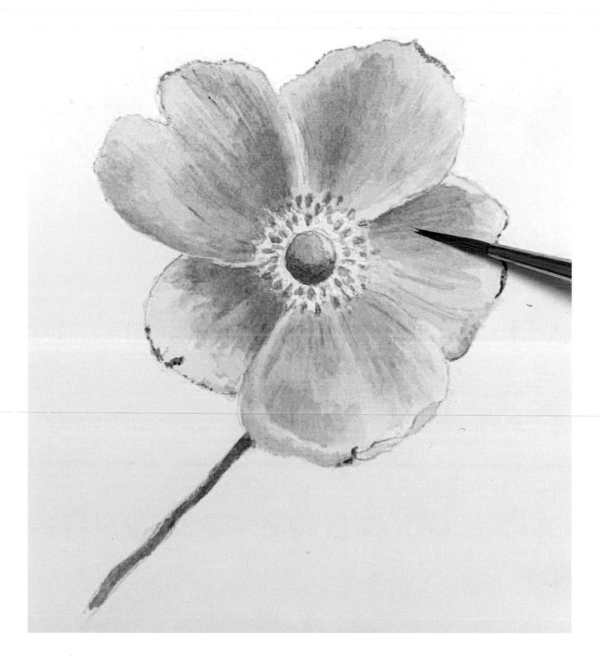

To finish, add light veils of cobalt blue (the water is barely tinted) to reinforce the shadows. Sepia may also be used in the darker parts of the flower, especially the reflective shadows of the petals. The edges of the half-faded brown petals are enhanced with sepia. Paint the stem with burnt sienna.

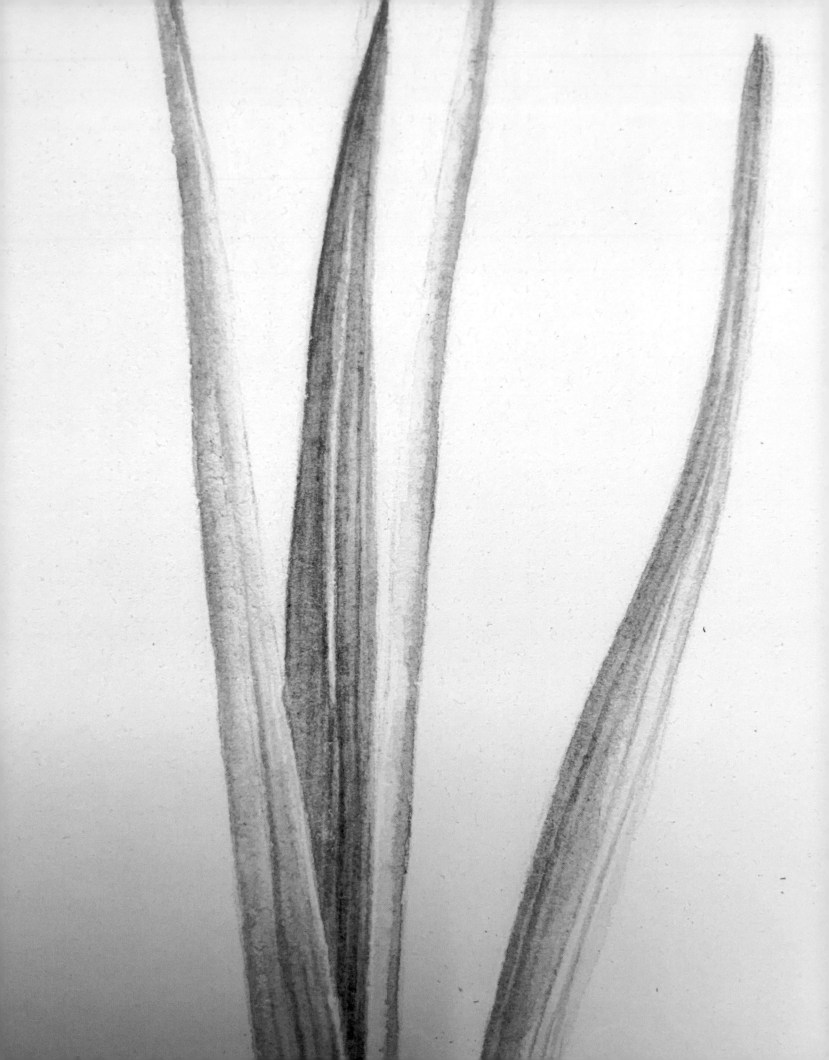

CHAPTER 4

SIMPLE LEAVES:
DAFFODILS

Painting shades of green takes practice. In order to avoid monotony in the rendering of foliage, a variety of hues should be used to take into account light and shadows. You need to prepare three or four different shades: first, create a warm green that uses a lot of yellow (blend new gamboge and Prussian blue); then, a cooler, more bluish shade can be made by adding cobalt blue to the first mixture; and finally, create a third shade by adding sepia or carmine to the second mixture. With this basic palette, you can paint almost any leaf; you just need to vary the mixes when painting a new plant. These washes should be prepared in large quantities. A very dark green can be achieved by taking the first green mixture (new gamboge and Prussian blue) and adding indigo.

— FIRST WASHES —

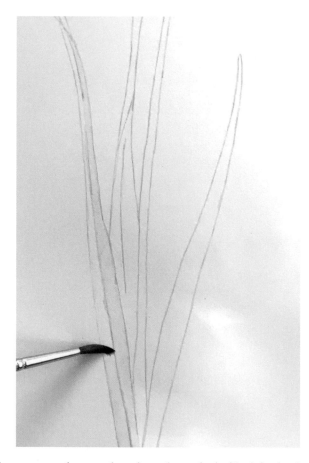

The warmest hue is placed on the right half of the leaf; the left half is filled in by sliding the brush, which is full of paint.

Add shadows using the third mixture – the one to which sepia (or carmine) has been added.

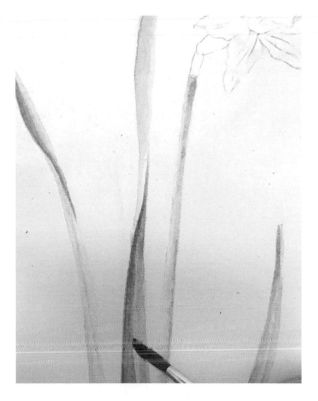

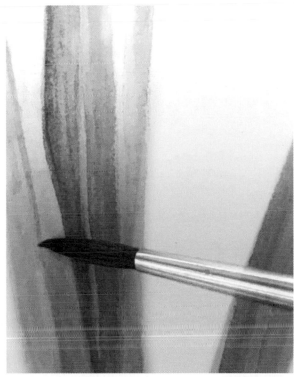

Paint the highlights and shadows with the second mixture, the cooler green to which cobalt blue has been added.

Continue to paint all the leaves in this way. The stem is painted with the warm green (a lot of new gamboge and a little Prussian blue).

For the finishing touches, draw the veins with a very fine brush and deepen the shadows with the fourth green. The contour can be accentuated with very fine stripes, barely thickened to mark the veins of the leaves. To make the work a bit easier, consider turning the paper horizontally.

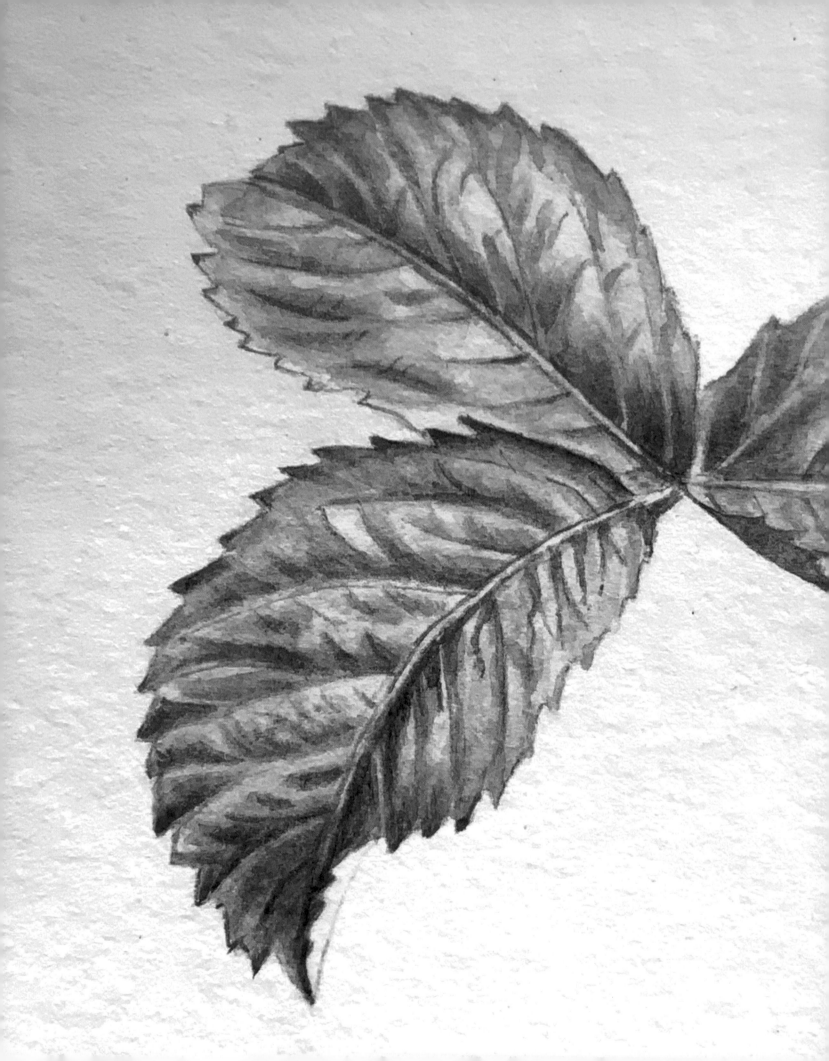

CHAPTER 5

COMPLICATED LEAVES:
ROSES

A wide variety of green shades can be made from Prussian blue, new gamboge, cobalt blue and sepia or carmine. Use just a small amount of sepia or carmine to give a natural tone to greens in botanical paintings. Practising the mixing of colours is essential for the artist; keep a sheet of watercolour paper next to your palette for testing colours as you prepare and mix them.

A drawing of rose leaves can be found on page 176.

— THE WATERCOLOUR SKETCH —

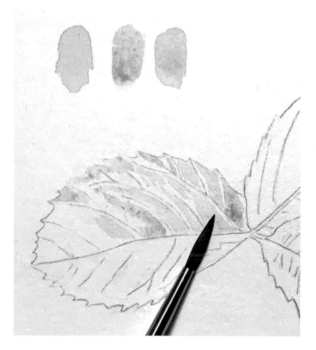

Prepare three different greens to resemble those at left, above the leaves: the first is made from new gamboge, Prussian blue and a hint of sepia. For the second green, use the first mixture and add cobalt blue. And for the last shade, simply add sepia to the second mixture.

The intervals between the ribs are painted separately.

— ANALYSING COLOUR —

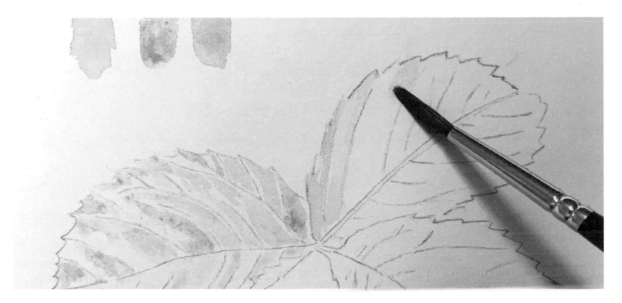

Note that for the left leaf, the mixture with cobalt blue was used. Redouté's pupil, Antoine Pascal, said, 'The real colour of a leaf is only found in the half-tone; a leaf, which at first appears uniformly green, should not be painted entirely with the same green. The highlighted part will take on a bluish-grey tint; the half-tone, which comes immediately after, will take on the real colour of green of the leaf, which then changes again in the shadows.'

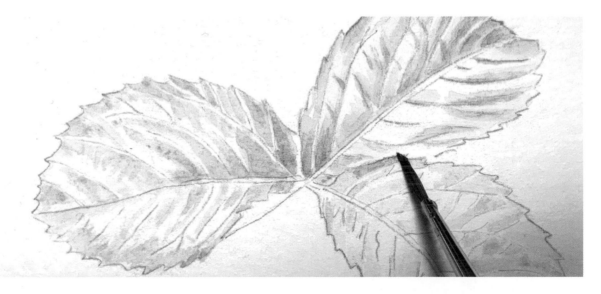

Accentuate the darker parts. Do not hesitate to turn the paper horizontally to facilitate the work. Let the paint dry.

From time to time, in order to blend the colours and give more softness and texture, a light wash can be painted over the entire leaf using either a very diluted amount of the same green as the leaf, or simply plain water.

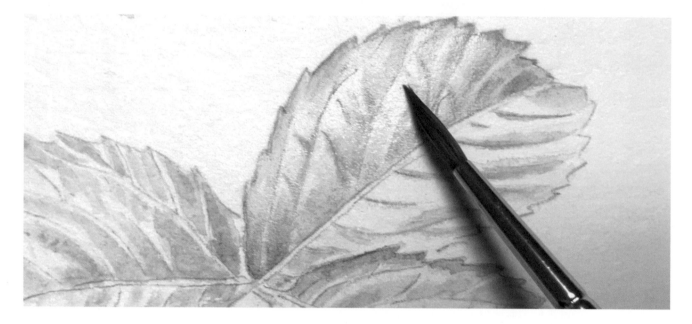

– FINISHING TOUCHES –

Begin painting the final details with a finer brush. Then, to avoid stiffness, glaze over it with a wash of cobalt blue mixed with a tiny amount of sepia or carmine.

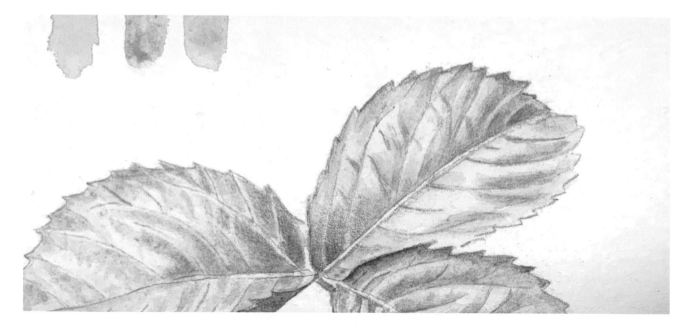

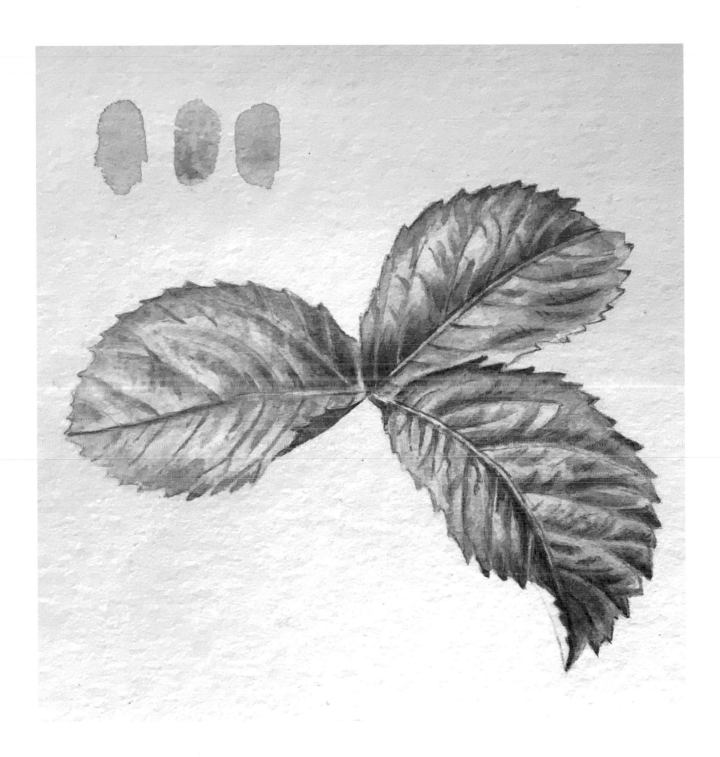

Finishing touches are important, and make it possible to smooth over the separations that may have arisen during the initial application of colour. It is important to emphasise shadows and highlights to give volume to the leaves.

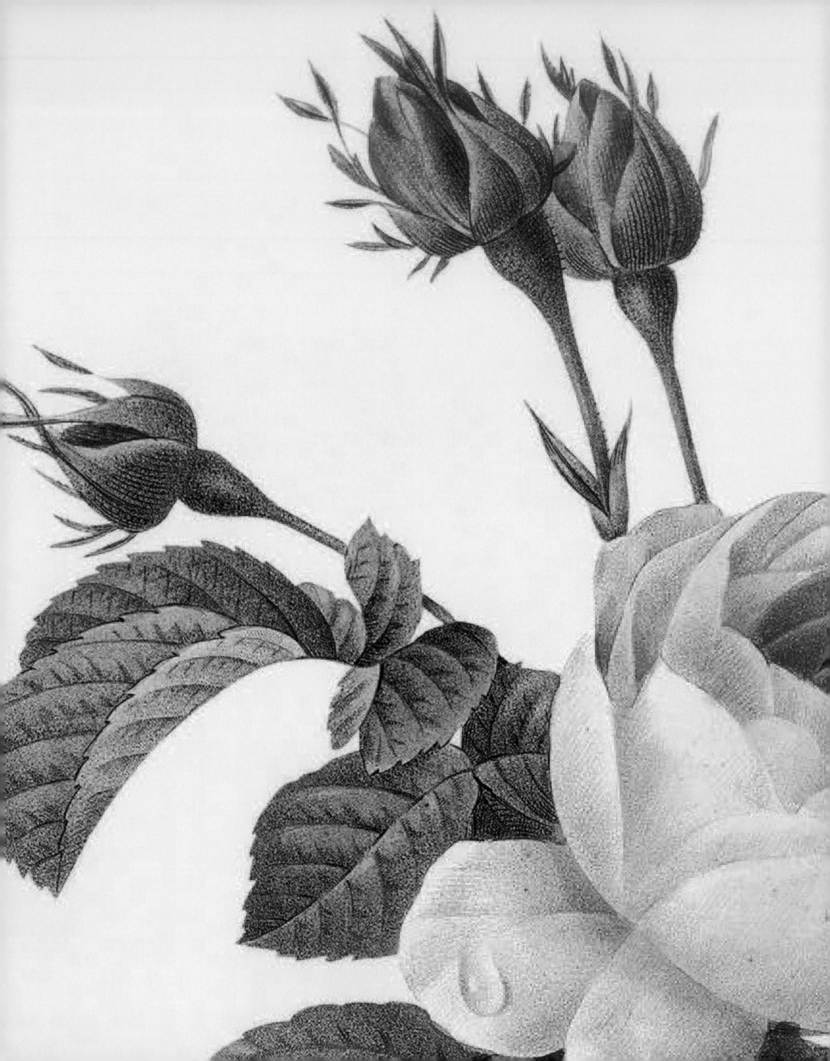

CHAPTER 6

ROSEBUDS

The rose is often considered a difficult flower to paint; its design can be quite complex because it has so many petals. The rosebud is a good subject to begin analysing colours and shapes. Let's start, then, with a simple exercise: painting a rosebud.

If you like, use the rosebud drawing on page 177.

– PAINTING A ROSEBUD –

COLOURS:

Prepare a shade of new gamboge and carmine for the sketch.

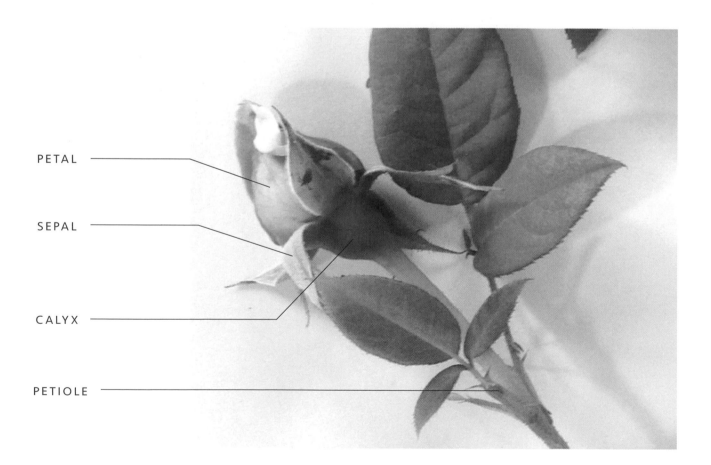

PETAL

SEPAL

CALYX

PETIOLE

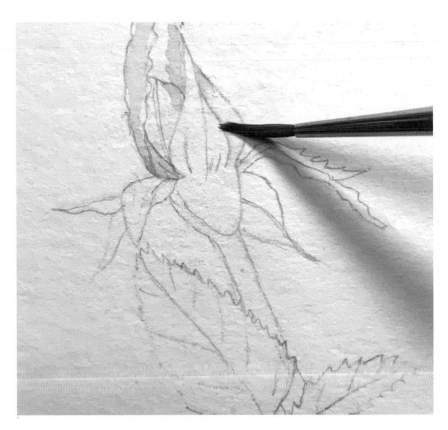

Start by filling in the rosebud on the left side with carmine; then, as illustrated, continue on the right with new gamboge. Also add yellow on the left of the sepal.

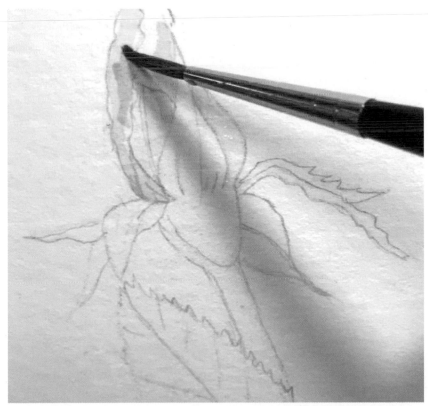

Add carmine to intensify the more densely coloured areas.

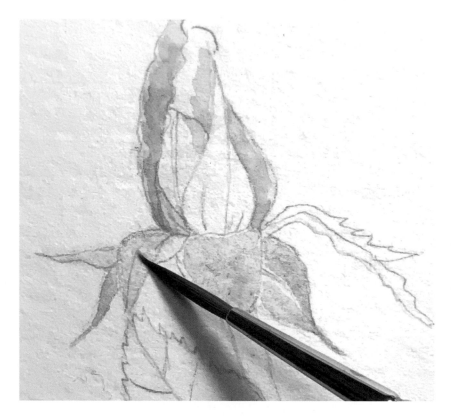

Start painting the sepals with different shades of green: first, the one made from Prussian blue, new gamboge and sepia; then add a bit of cobalt blue to the first green mixture to achieve a greyish-green for the inside of the leaves.

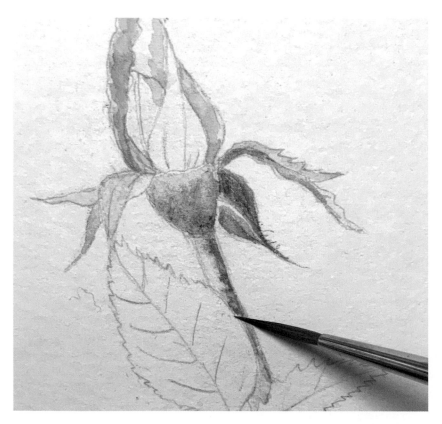

For the stem, begin by lightly wetting the paper. Then apply the first green mixture (Prussian blue, new gamboge and a little sepia). Emphasise the details of the sepals and calyx with a darker green made from Prussian blue, new gamboge and a very small amount of indigo.

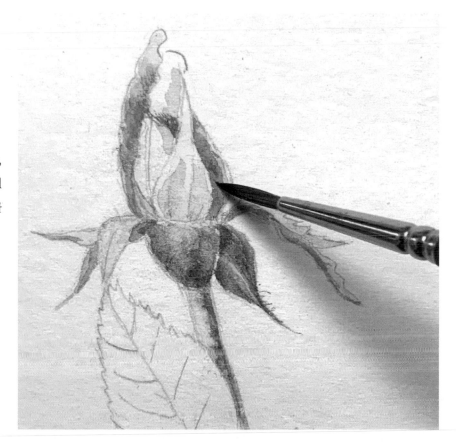

Use carmine to finish the flower, painting the details with small strokes; return several times if necessary.

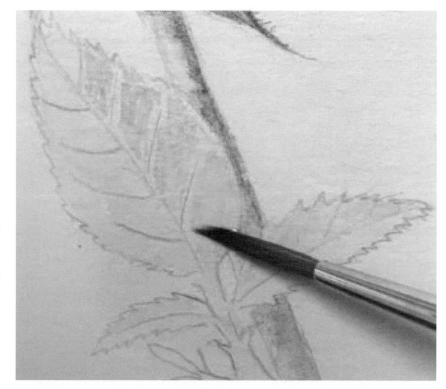

Place a wash of water barely tinted with new gamboge over the entire leaf. Then, after it's dry, paint the leaf with the first green mixture (Prussian blue, new gamboge and sepia) between the veins, leaving light – or even white – areas at the veins. When it is dry, erase the pencil lines with a very soft eraser.

Complete the details in the sepals and calyx using very fine strokes or small dots; use sepia for dark browns.

Paint the parts between the veins of the leaf with the first green (Prussian blue, new gamboge and a little sepia), and add a touch of indigo. Allow this to dry. Then add more details: touches of sepia to the ends of the sepals and the borders of the leaves.

Finally, apply a very diluted carmine wash on the leaves and the petiole.

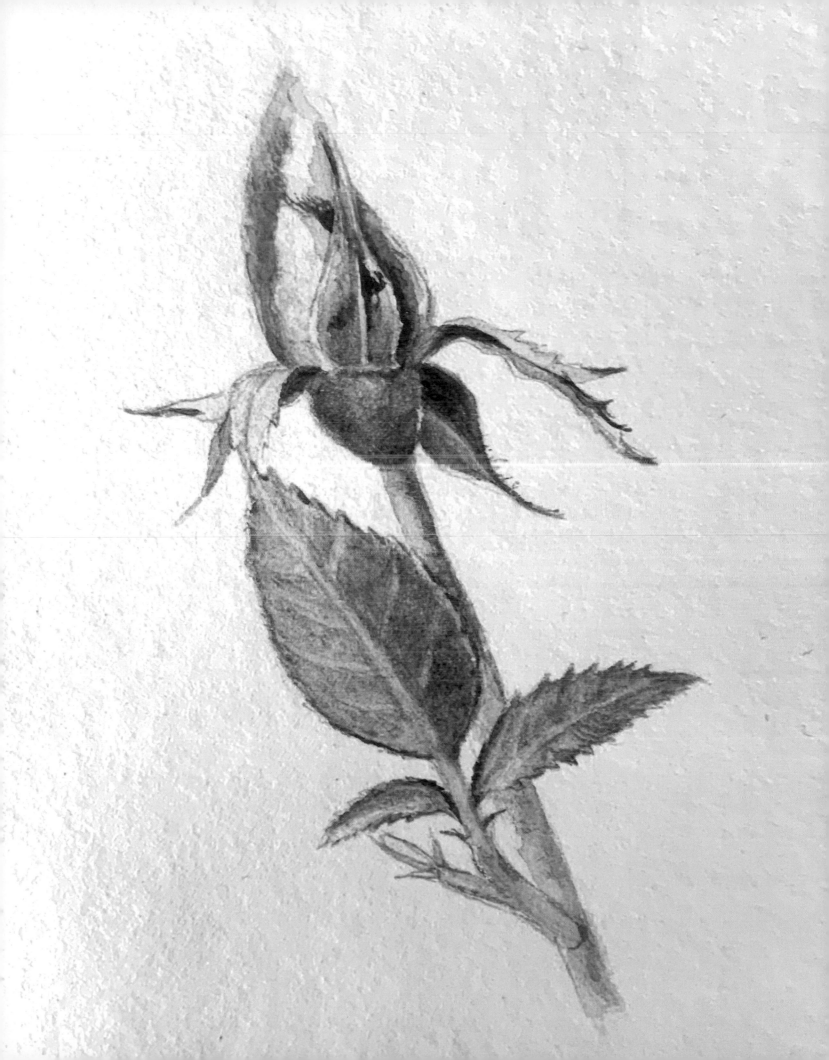

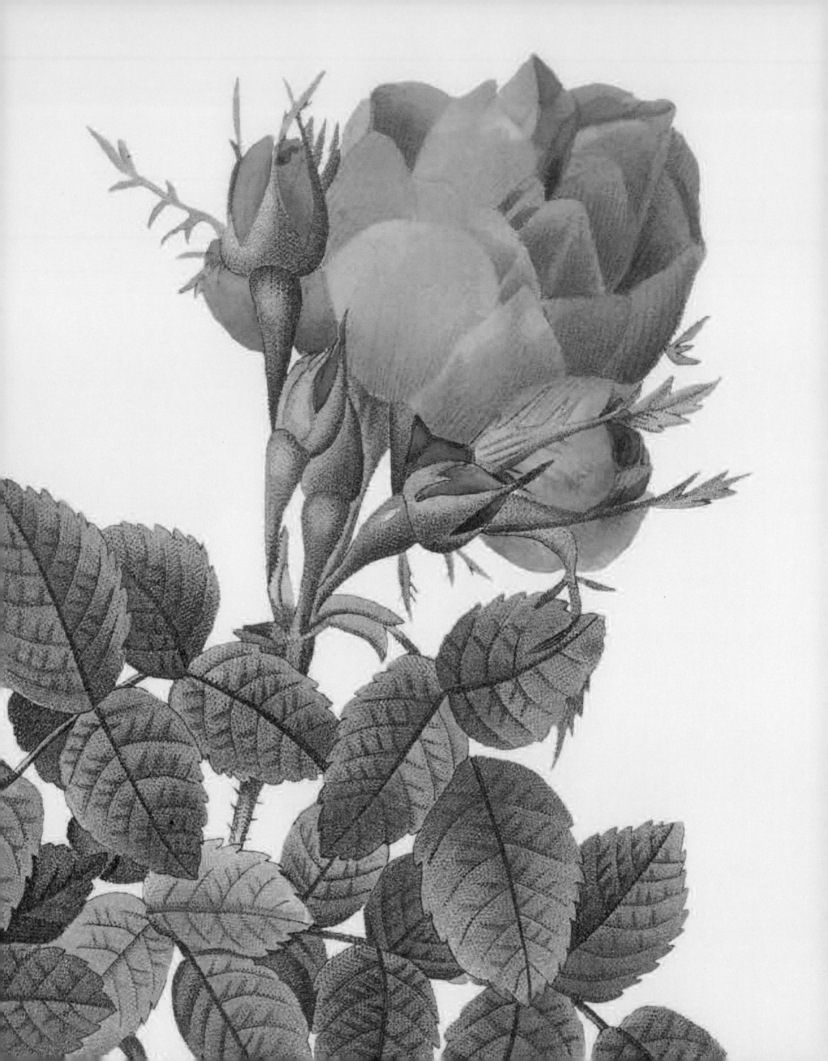

CHAPTER 7

SIMPLE ROSES

After the rosebud, let's paint a fairly simple rose. Feel free to use the drawing on page 178.

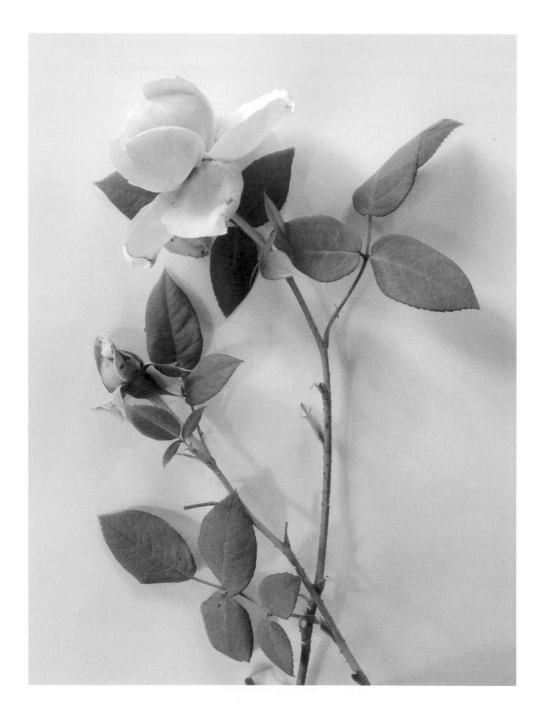

The first stages are not more difficult than that of the Japanese anemone (Chapter 3). However, take time to prepare the colours – make them quite runny and in large quantities.

According to Redouté, three shades are used for pink roses. For the lightest parts, mix a lot of carmine, which will dominate the tone with a small amount of cobalt blue; also add some neutral shade. For the shadows, use a mixture that is predominately carmine with some Prussian blue, neutral tint and a very small amount of cobalt. The third colour consists of carmine and new gamboge; this will be used for the petals in the centre. However, as the flower is closed in this exercise, the third colour is not needed. In addition, prepare a quantity of water tinted with new gamboge.

The top row (right) shows the three colours for the rose. *From left*: pink for the light parts; a darker pink for shade; and new gamboge.

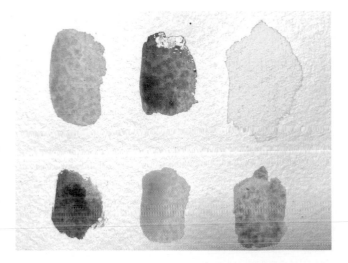

The bottom row shows the three greens for the leaves and stem. *From left*: A blend of Prussian blue, new gamboge and sepia (darkest shade); the first mixture, plus new gamboge; and finally, a blend of new gamboge and Prussian blue with some cobalt blue.

With very diluted new gamboge, outline the base of the petal in the foreground and the petal opposite. The other petals are painted with the pink for the light parts: carmine and cobalt blue mixed with a neutral tint. Don't forget to leave the white of the paper free for highlights.

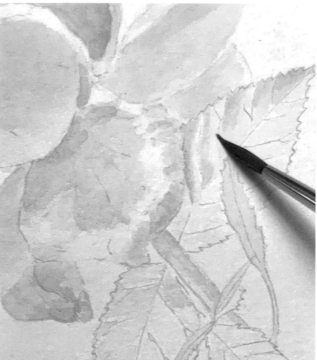

Paint the stem with the green consisting of Prussian blue, new gamboge and a little sepia.

Outline the leaf with the same green.

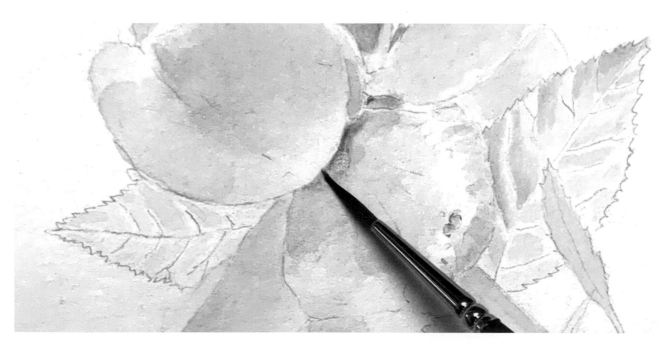

Shade the part under the petal and add the darker details with a mixture of carmine and burnt sienna.

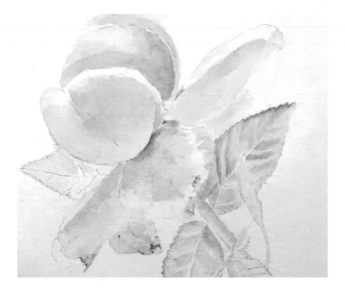

Continue to paint all the petals in the same way. Add the wilting marks of the petals with sepia mixed with carmine.

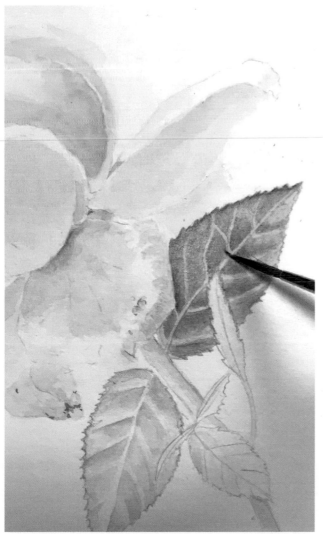

Next, accentuate the details of the leaves by adding the darker green and revealing the veins. At this stage, when the painting has dried, erase the pencil lines on the flower and leaves with a soft eraser. Redouté left the pencil lines visible; they were an integral part of his work and indicated shadows and certain details. However, for this very lightly coloured flower, it is best to erase the pencil marks to avoid weighing down the painting – especially on the petals.

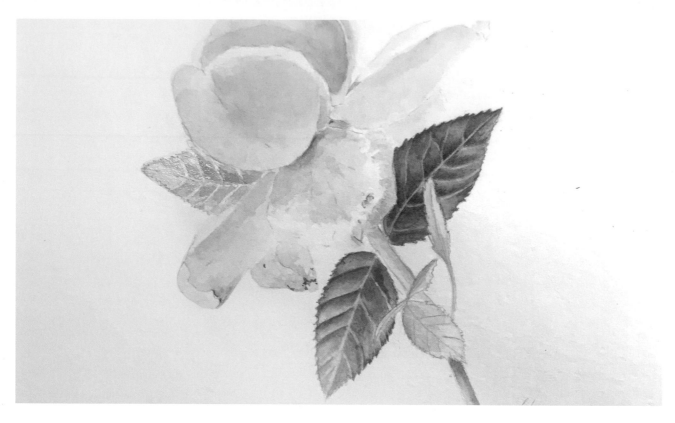

In the same way, reinforce the leaf with the dark green and the green to which you added cobalt blue. For the leaf on the left, apply a light wash of new gamboge and let it dry before filling it out with the darker green. Apply a little water and accentuate the stem. Place a diluted light green (barely coloured water) wash on the leaves on the right to add softness.

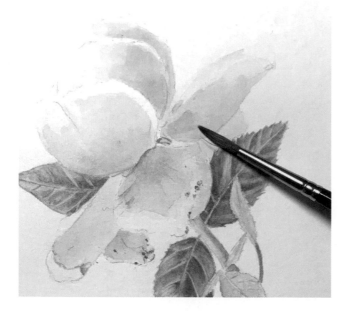

Paint the shadows on the petals with the darker pink: carmine with a small amount of Prussian blue, neutral shade and a tiny amount of cobalt. Give volume to the stem by darkening the right part with the dark green mixture.

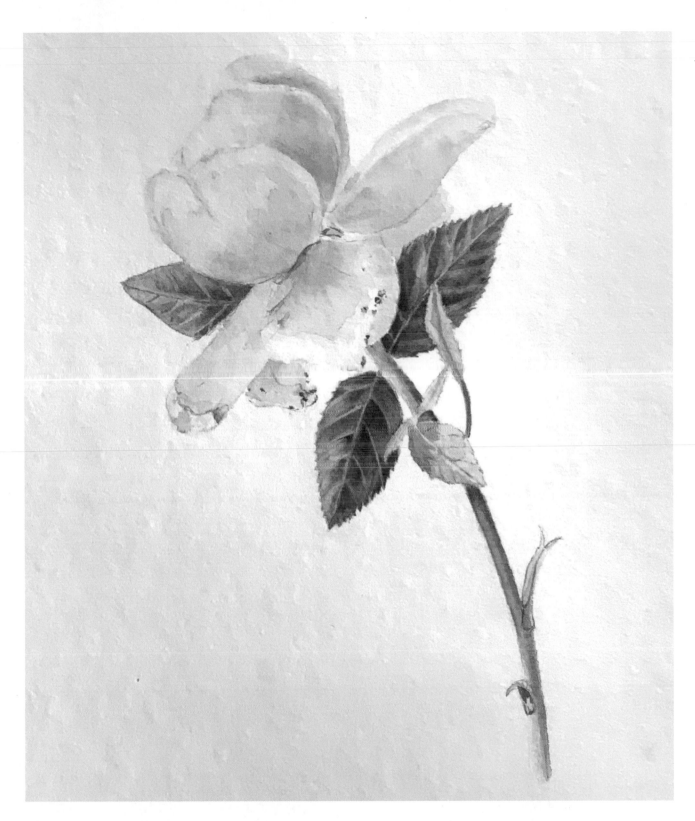

Paint the details on the stem.

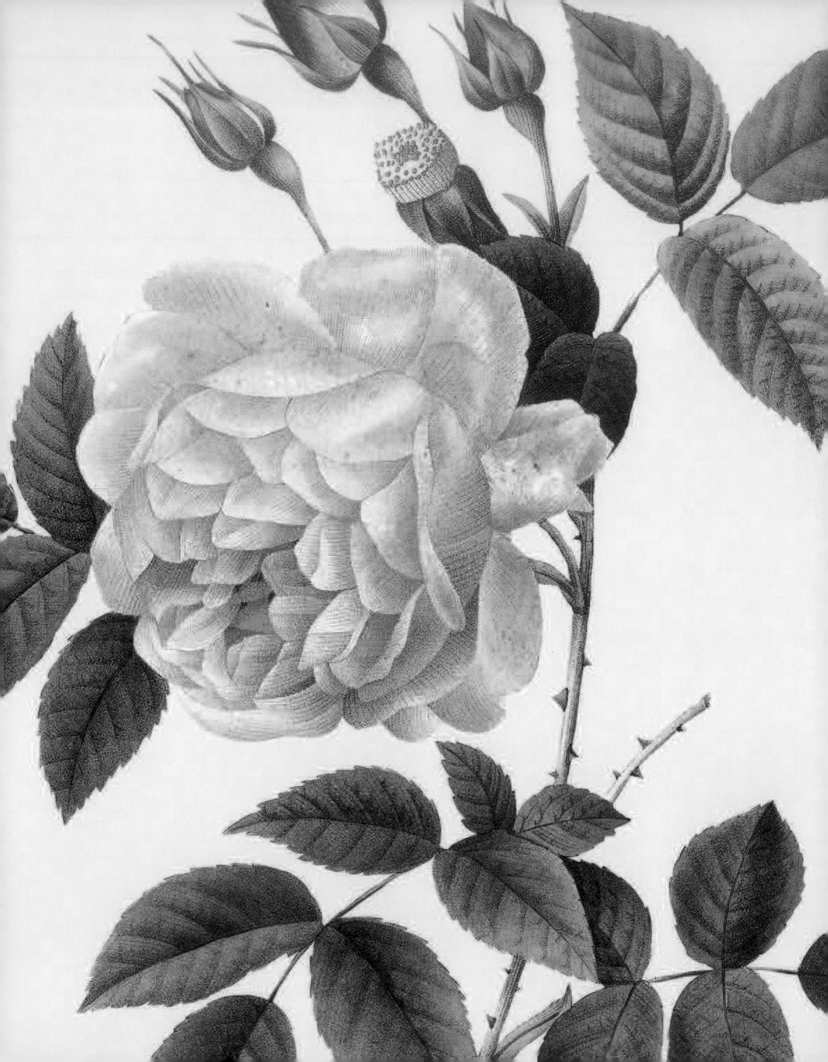

CHAPTER 8

INTRICATE ROSES

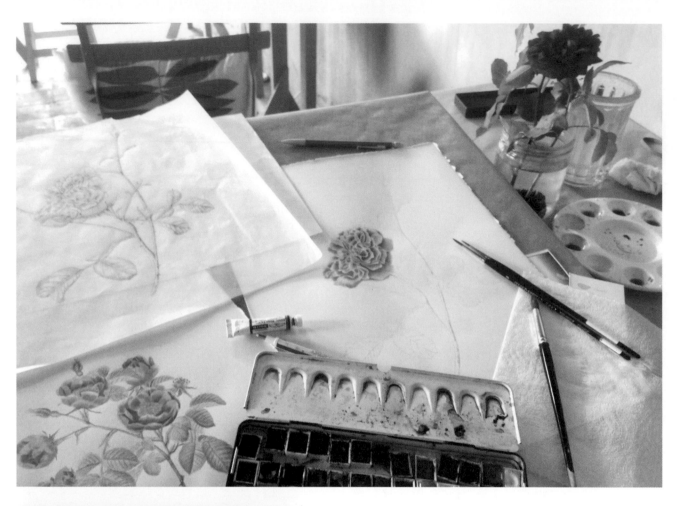

The above photo shows my work table. On the left side is a botanical painting by Pierre-Joseph Redouté that I copied. It will serve as an inspiration for the next exercise: the rendering of the leaves with precision and variety.

In this exercise, it is the drawing that is the most complicated. Contrary to what one might expect, the painting is quite simple, although it takes a little more time because each petal must be done separately. Redouté's method of applying several colours simultaneously is all the more evident here, and results in adding more energy to the strong colours.

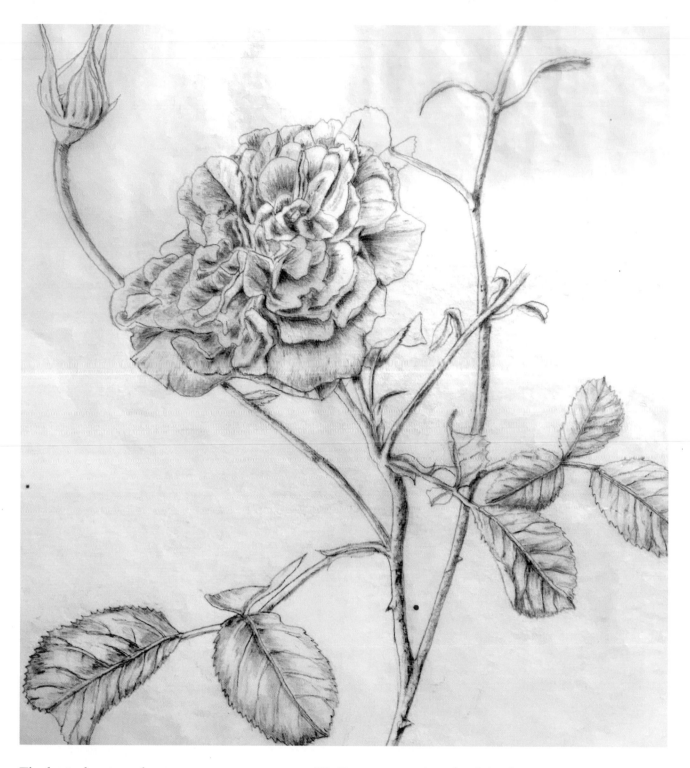

The basic drawing of an intricate rose is on page 179. Execute a tonal study of the flower in pencil in order to understand shapes, shadows and highlights. This preliminary work is vital, and it becomes the model we refer to constantly while painting.

COLOURS:

New gamboge, carmine, cobalt blue, Prussian blue, sepia, indigo and a neutral tint (most watercolour paint ranges will include one).

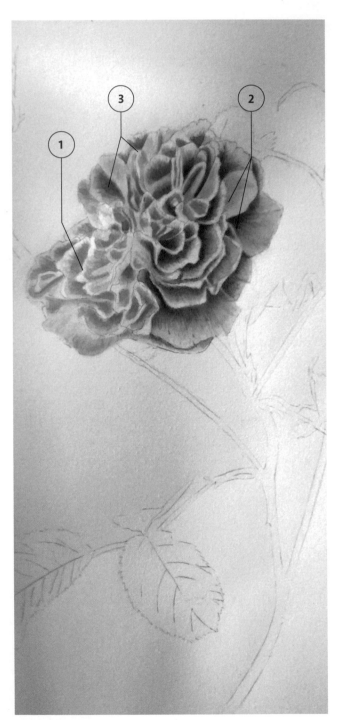

For the flower, prepare three colours in sufficient quantity on the palette for the washes and details. The first colour, for the lighter parts, is carmine. The second colour, for the shadows, is a mixture of predominantly carmine with Prussian blue, neutral tint and a little bit of cobalt. The third colour, for the petals, consists of carmine and new gamboge.

Prepare some water tinted with new gamboge and apply it to the stem, leaves and sepals of the bloom.

The photo illustrates stages in the execution of the painting. Step ①: Apply a wash of the first colour to each petal starting from the lightest part; wet it with a little clear water, then apply the first rose-tinted mixture.

Step ②: Apply another wash with the first <u>mixture</u> to reinforce the colour. Then, after it has dried, add the details with the second shade, using small strokes in the darker parts.

Step ③: Apply the third mixture (carmine and new gamboge). Then, as before, add the details and shadows with the second mixture, using small strokes.

Place a glaze of water lightly tinted with new gamboge to the stems, leaves and buds.

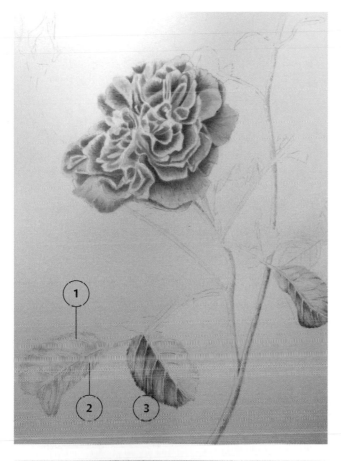

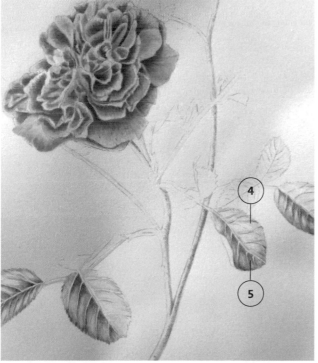

Begin painting the leaves with the same technique. Prepare three different greens: the first is made from new gamboge, Prussian blue and a touch of sepia; the second one is composed of the first mixture with the addition of cobalt blue; and the final one is composed of the second mixture with a touch of indigo.

(1) Paint the left leaf with the first mixture. Allow this to dry.

Step (2): Place another glaze of new gamboge-coloured water over the right section to add shine and moisten the paper.

Step (3): Shape the leaves with the second (darker green) mixture, adding additional washes along with small strokes and dots. Create the veins with a slightly darker shade of green. Begin painting the stem with the first green (new gamboge, Prussian blue and a touch of sepia). Moisten the leaf with a little water before applying the colour.

Deepen the shadows on the leaves and the flower by adding more pigment, either using small touches or by adding another wash if the colour is too pale. Underline the central rib of the leaf if the pencil is not sufficiently visible. The more you add colour to the shaded parts to suggest depth, the more the flower and the leaves will acquire texture, as shown in (4) and (5).

By keeping an eye on the pencil tonal study, I can easily check that the painting reflects the contrast between the light and dark areas of the rose that were emphasised when I drew it.

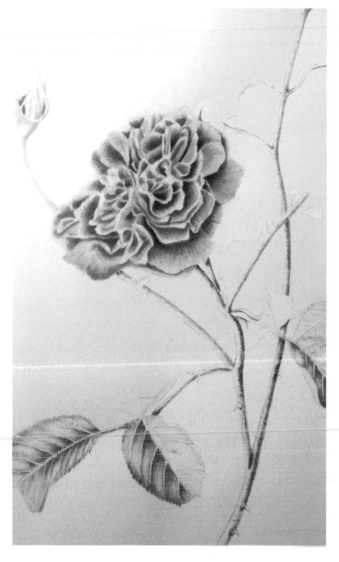
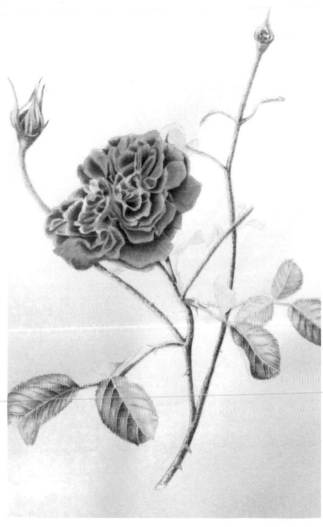

Continue painting the blooms with a mixture of cobalt blue and carmine (which will dominate) and the neutral shade; when that has dried, add the darker details using small touches of the second shade (predominantly carmine with Prussian blue, neutral shade and a tiny amount of cobalt).

Finish painting the leaves and the stems by adding points of darker green in certain places. Leave a fine white border between the petals, and a few other white spaces to bring out the light.

Deepen the shadows in the centre of the petals, and add green pigment on the stem to strengthen it.

At this point, it is good to stop working and allow the watercolour to 'rest' for a few days. Start or continue another painting.

After letting the painting rest, take a new look: finish the details, accentuate the shadows and underline the veins. Check that the texture of the leaves is well rendered. You should not try to include every detail, but leave some lighter areas, especially in the leaves at the back. (*See* Chapter 19: Some Observations on Perspective and Composition.)

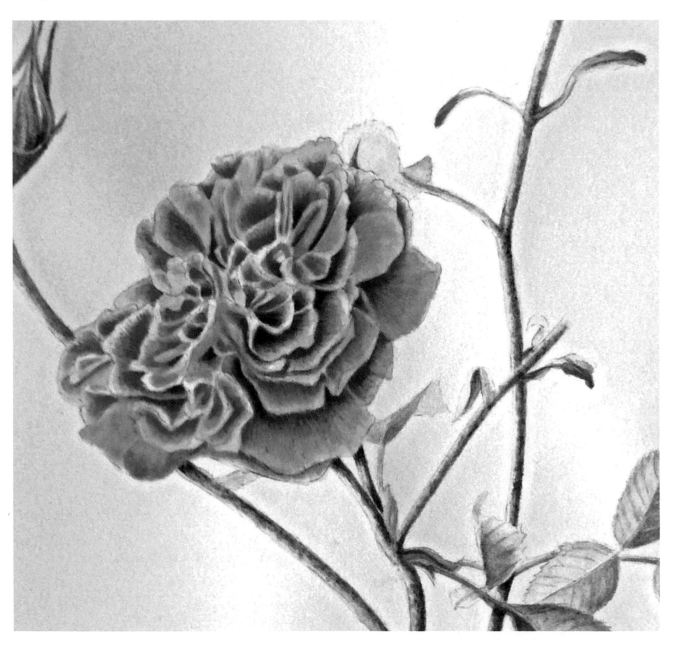

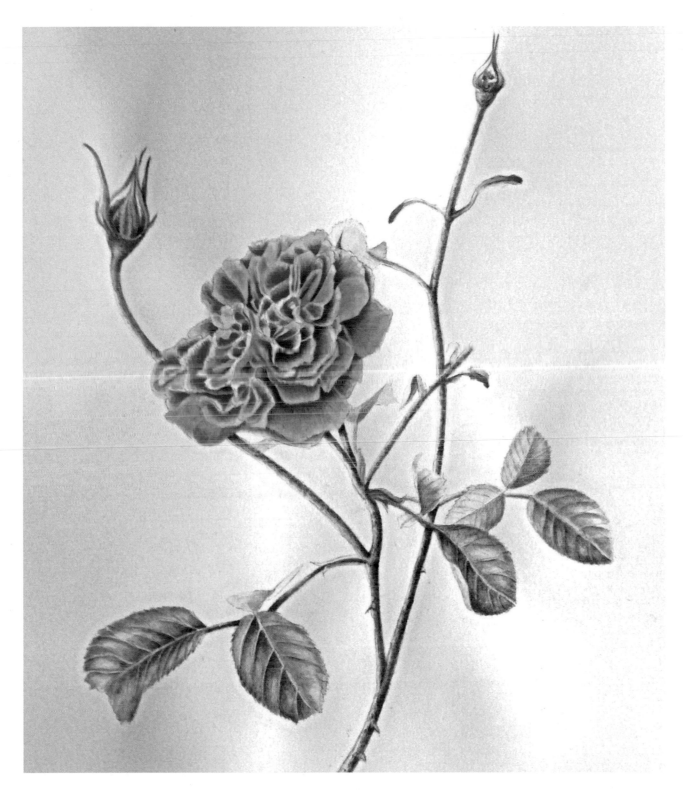

ROSE

Watercolour on Arches paper, 39 x 29cm

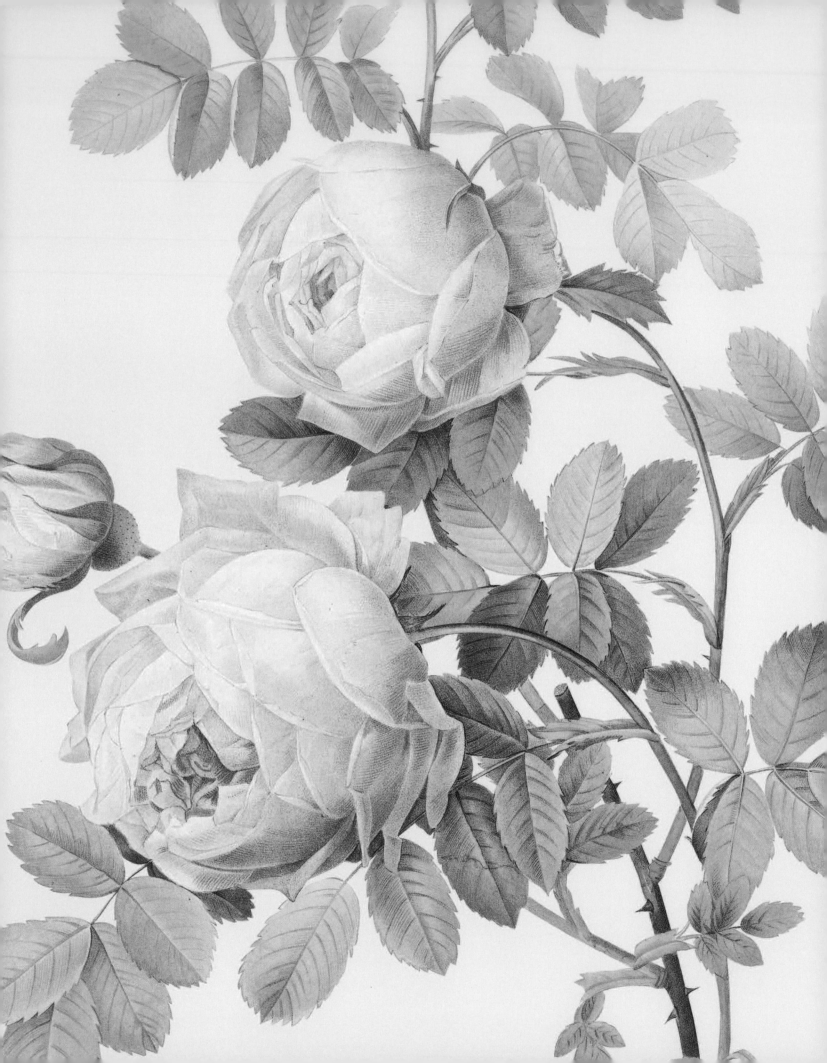

CHAPTER 9

YELLOW ROSES

COLOURS:

New gamboge, Indian yellow, saffron, natural sienna, burnt sienna, carmine, sepia and neutral shade. The drawing is on page 180.

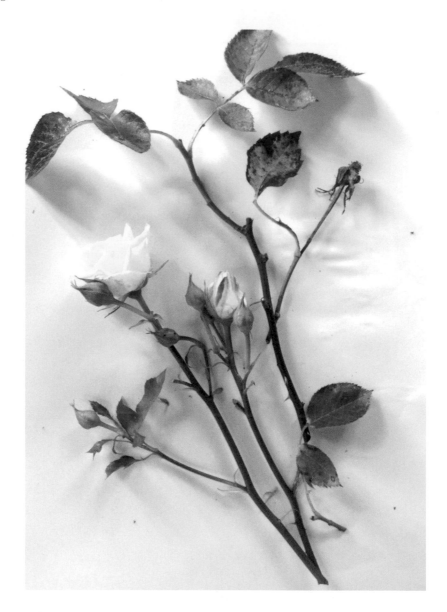

Paint the yellow flowers using a very diluted new gamboge; it will result in a pale and fresh tone. Indian yellow, which produces a bright golden yellow, is used to strengthen and give radiance. Saffron is rarely used undiluted, but rather as a wash to give shine to the yellow tone. I did not use saffron in this composition, but I did use it in 'Yellow Roses and Lavender' on page 93. Shadows are added with natural sienna and sepia; here I used the neutral shade.

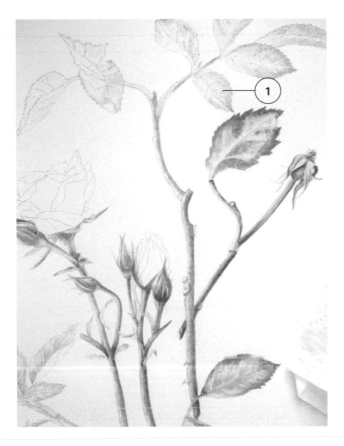

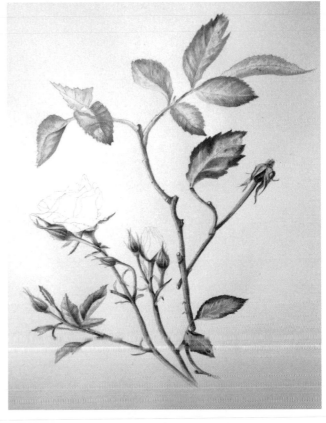

For the leaves and stems, work in the same way as you did on the pink rose in Chapter 7, but first use a very diluted wash of new gamboge and natural sienna. See step ① on page 80.

After applying the basic washes, add some finishing details and smooth over any separations. Apply small brown crosshatching for damaged (or withered) leaves. Underline the main veins and darken the shaded parts to suggest depth and texture on the leaves. In the same manner, using carmine, paint and add detail to the buds.

Start painting the petals with new gamboge. First, apply water in the lightest area, and then take the brush full of paint and descend gradually from top to bottom. Leave a thin, dry border between the petals and the edges that turn outward. Paint the rosebud in the same way. After it is dry, add a wash of Indian yellow to give shine and warm up the golden yellow. Apply small, fine strokes of carmine mixed with Indian yellow to obtain a warm red.

Reinforce the flower by working on the details using new gamboge mixed with a little neutral shade and natural sienna. If the result is a little too dry, add a glaze of Indian yellow, working carefully. Allow it to dry.

YELLOW ROSE

Watercolour on Arches paper, 51 x 41cm

Deepen and intensify the colours of the leaves, stems and buds by adding small touches of the more concentrated mixtures – in particular the browns (burnt sienna, sepia and the neutral tint). Darken and emphasise the ends of the leaves with a very dark green (use a little of the green you made for the painting, and add a touch of indigo). At this stage, you should not overwork the details. Some leaves are barely sketched.

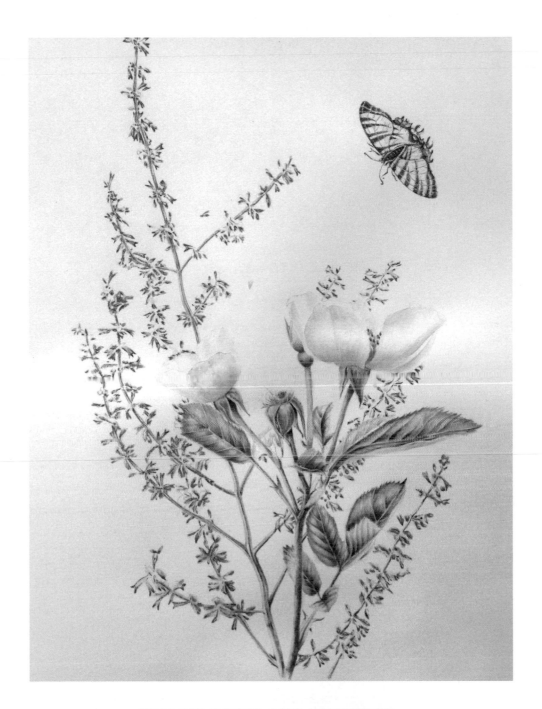

YELLOW ROSES AND LAVENDER
Watercolour on Arches paper, 57 x 38.5 cm

Here is another composition with yellow roses in front of lavender; purple is a complementary colour to yellow. Another watercolour, in which I used the yellow roses in a very different composition, can be seen on page 188.

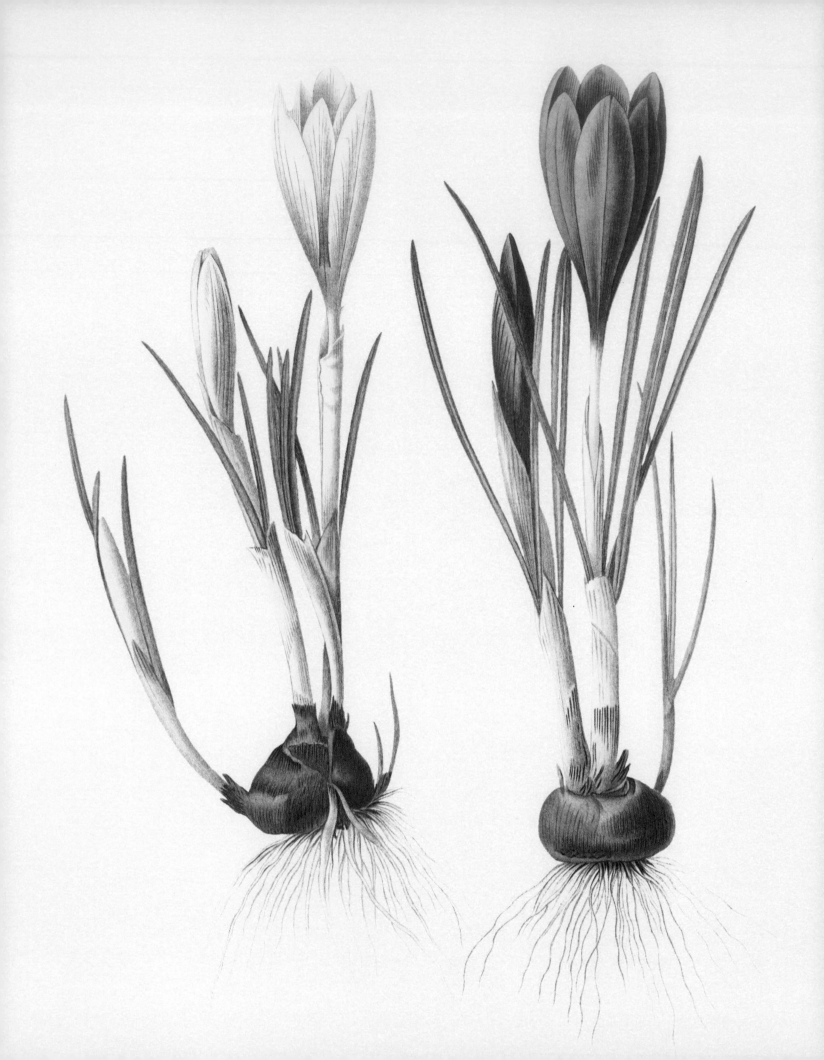

CHAPTER 10

BLUE FLOWERS: CROCUSES
(COPYING A REDOUTÉ WATERCOLOUR)

COLOURS:

New gamboge, natural sienna, burnt sienna, carmine, cobalt blue, Prussian blue and sepia.

Blue is a colour that was well made (pigment-wise) in the time of Redouté and stayed true to its original shade, giving good results. Make a large quantity of cobalt blue cut with a little carmine. Then prepare another mixture, using the first shade and adding more carmine to make purple.

After transferring the drawing (*see* page 181) onto watercolour paper, place a coloured wash of new gamboge on the leaves. Allow it to dry.

The leaves are delicate to paint, because they are very thin; apply a mixture of Prussian blue, new gamboge and sepia.

Intensify the greens with the same mixture, but with a little added carmine.

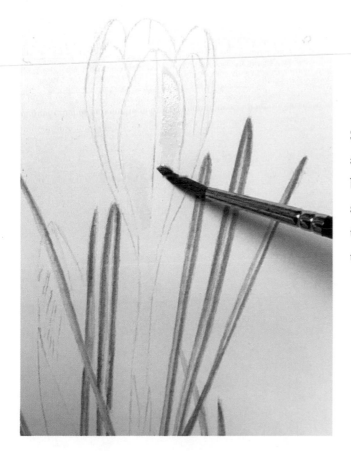

Start painting each petal with very diluted carmine and allow it to dry. Then use a wash of the main cobalt blue mixture on all the petals. Don't forget to leave a fine dry border between the petals; this will define them and suggest the reflections on the right. Allow the paint to dry.

First paint the bulb with a wash of natural sienna; then, when it has dried, add burnt sienna.

Add details with the fine brush; paint the darker parts with precise strokes, using a mixture of burnt sienna and sepia. Then use sepia on its own in the darkest areas.

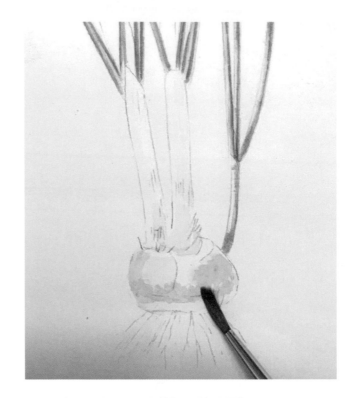

Add the details of the petals with very fine strokes of the purple mixture, defining the shapes. In the photo, you can see an unpainted white border to the right of the central petal.

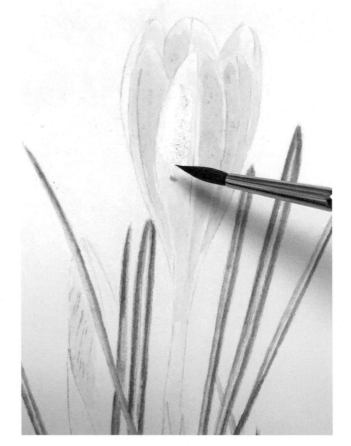

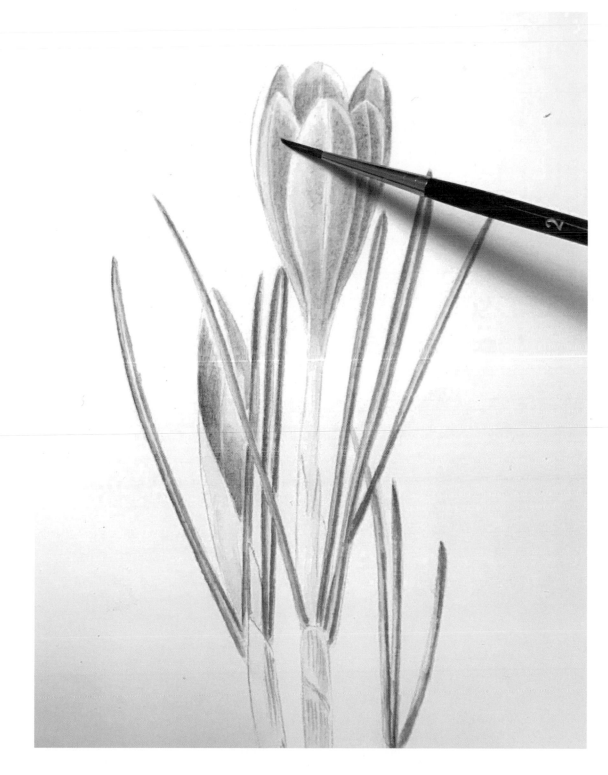

Paint the stems with new gamboge with an added touch of natural sienna. Using the fine brush, continue adding details using small strokes, just as you did for the bulb.

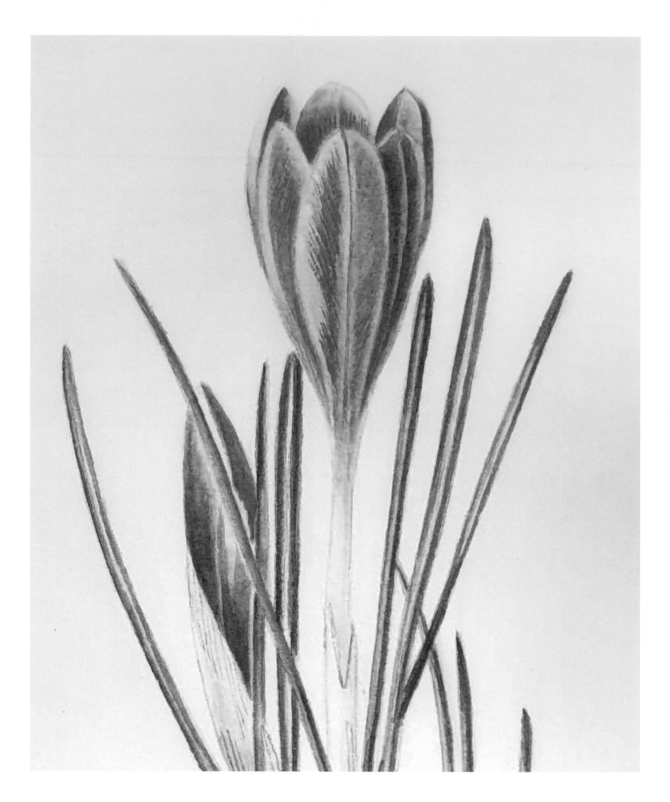

Intensify the colour of the bud with cobalt mixed with a touch of indigo. Draw the roots with new gamboge, and add the shadows in sepia.

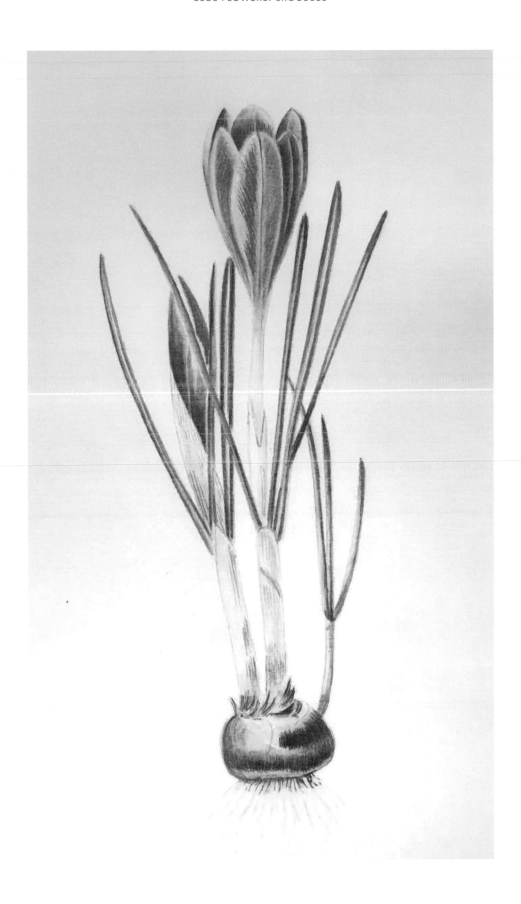

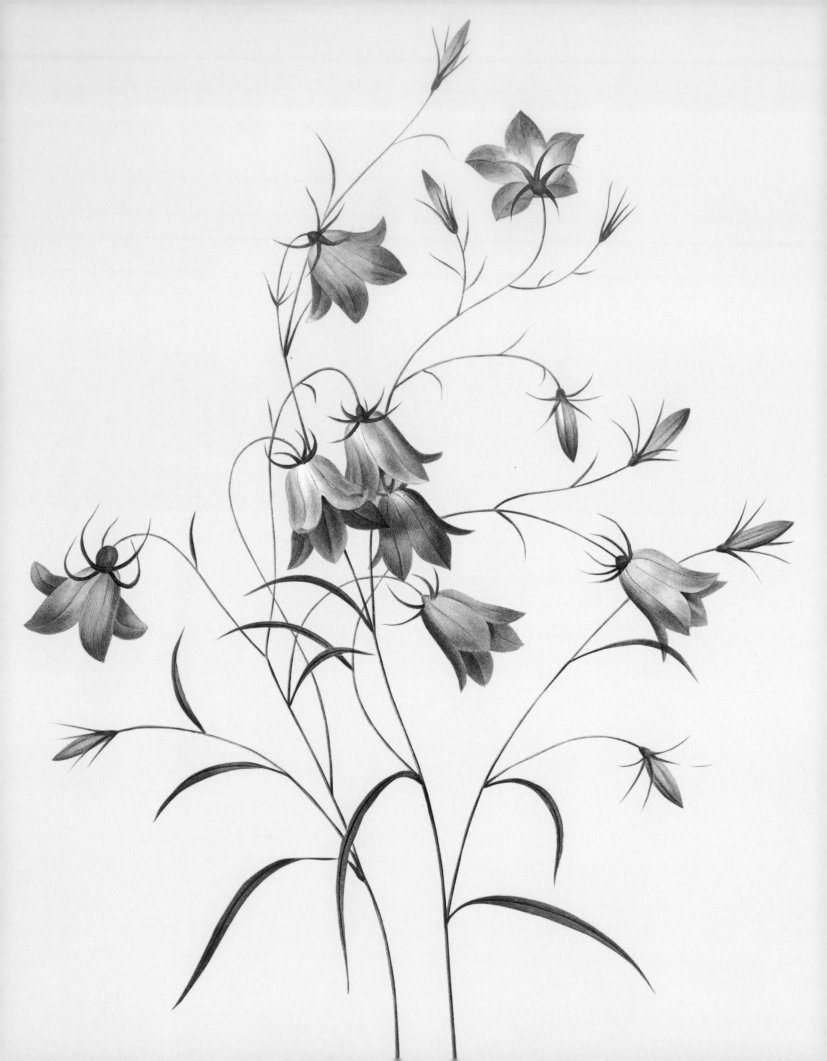

CHAPTER 11

MAUVE FLOWERS:
CAMPANULAS

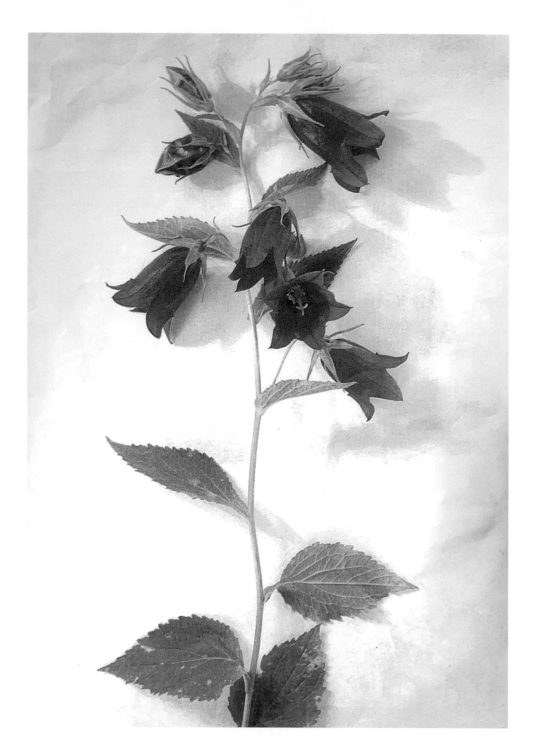

COLOURS:

New gamboge, carmine, cobalt blue, Prussian blue, sepia and indigo. Prepare a large quantity of carmine mixed with a tiny amount of blue cobalt. For the darker shadows, add more cobalt blue to obtain a violet hue.

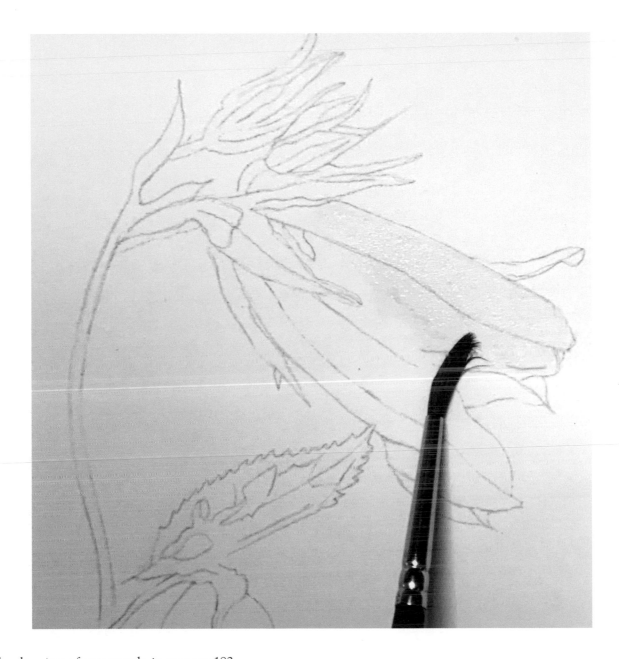

The drawing of campanula is on page 182.

Before beginning the sketch, place a light wash tinted with a little carmine on all the flowers.

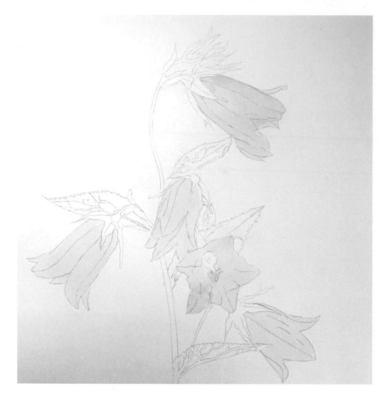

This is what the painting will look like after the wash has dried.

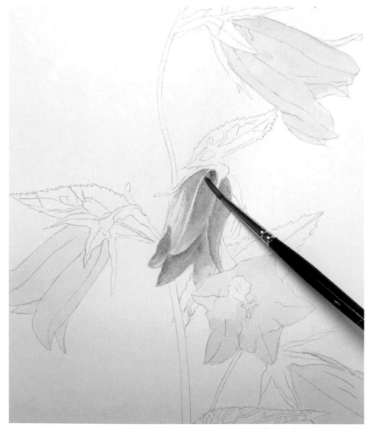

Begin painting with the mixture of carmine with a little cobalt.

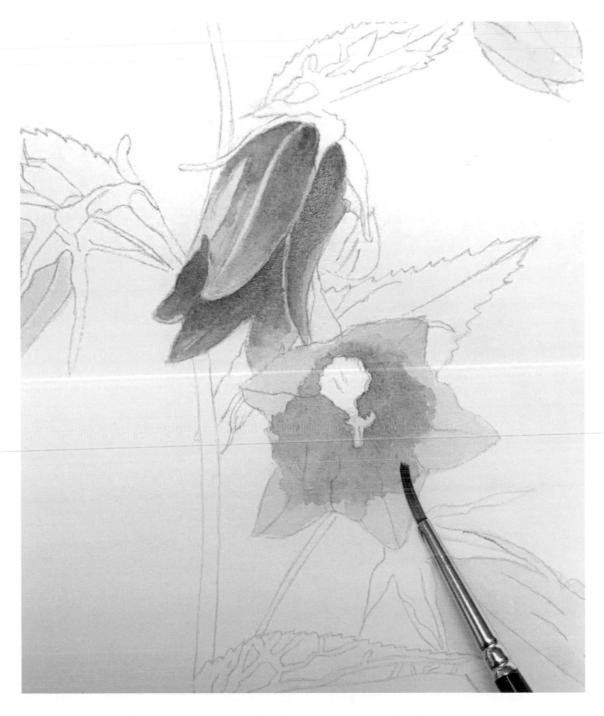

Continue painting with the second mixture, with more cobalt blue adding violet tones.

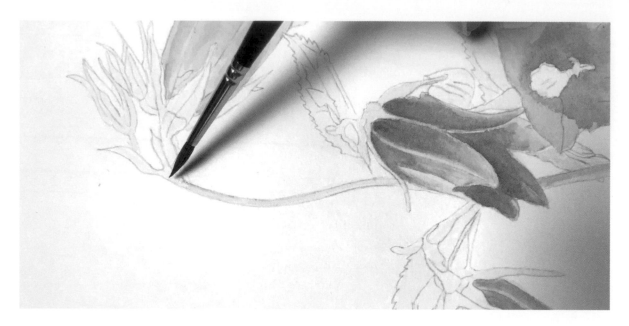

For the sepal and the stem, use a green made from new gamboge, Prussian blue and a very small amount of sepia. For the darker parts, add a touch of indigo to the first mixture.

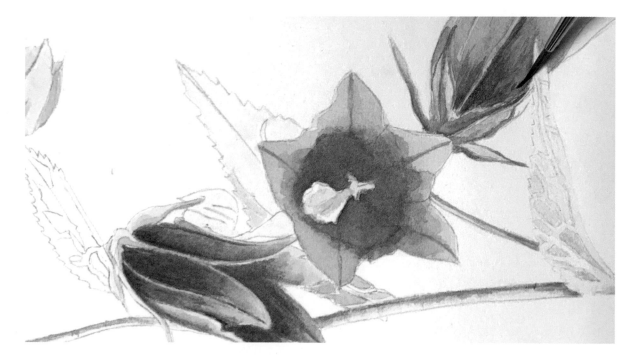

Start painting the finishing touches with a very fine brush for the violet tones on the petals. Use small strokes and crosshatching to emphasise the folds of the petals. This mixture contains more pigment. Using small strokes, darken the shadows to add depth.

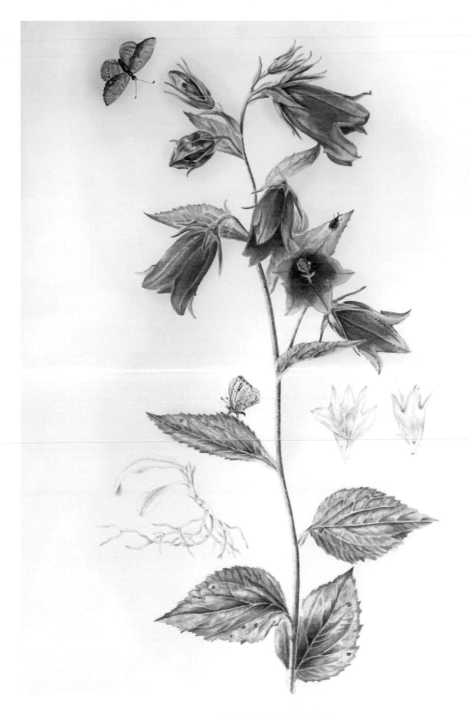

CAMPANULAS
Watercolour on Arches paper 57 x 38.5cm

The finished painting: some pencil drawings of petals and roots were added and, in order to bring life to the whole, a few insects were added too.

Pierre-Joseph Redouté and his brother Henri-Joseph both worked as illustrators whose works reinforced the descriptive text of the authors. Redouté painted a true and precise illustration of the whole of the plant, as well as the reproductive organs in Swedish botanist Carl von Linné's work on the system of sexual reproduction in plants. His drawings bring precision to the morphological details. Watercolour, thanks to its transparency, allows a number of details to appear in a remarkable manner.

It was botanist Charles-Louis L'Héritier de Brutelle who taught Redouté how to dissect plants. French naturalist and zoologist Georges Cuvier greatly admired de Brutelle, saying that 'His botanical works are well regarded in all of Europe for the exactness of his descriptions and minute research into the characteristics [of the plants] and the grandness and finish of the illustrative plates.' (Exhibition catalogue, Musée de la Vie Romantique, pages 23 (text) and 25, note 7.)

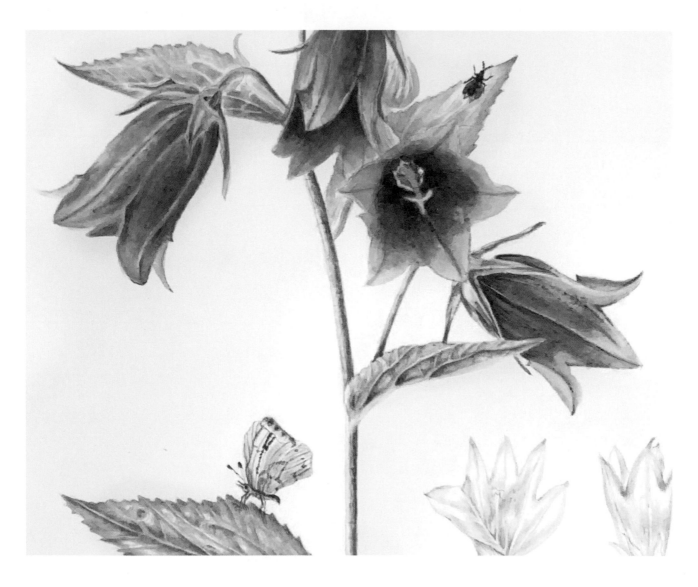

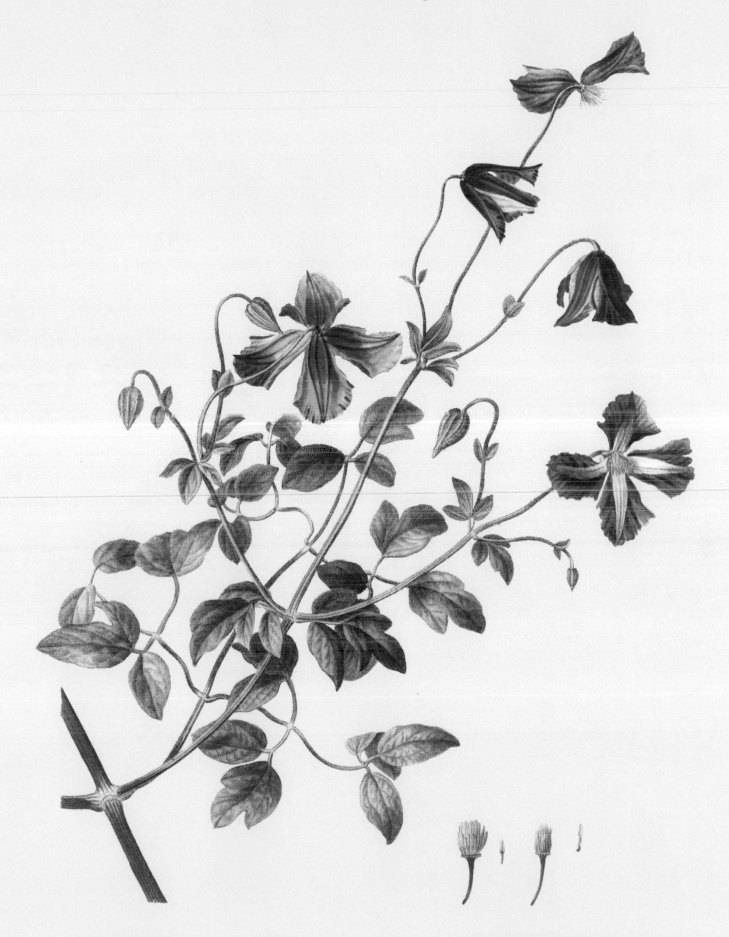

CLEMATIS viticella.

CLEMATITE bleue.

P.Bessa del.

Jarry sculp.

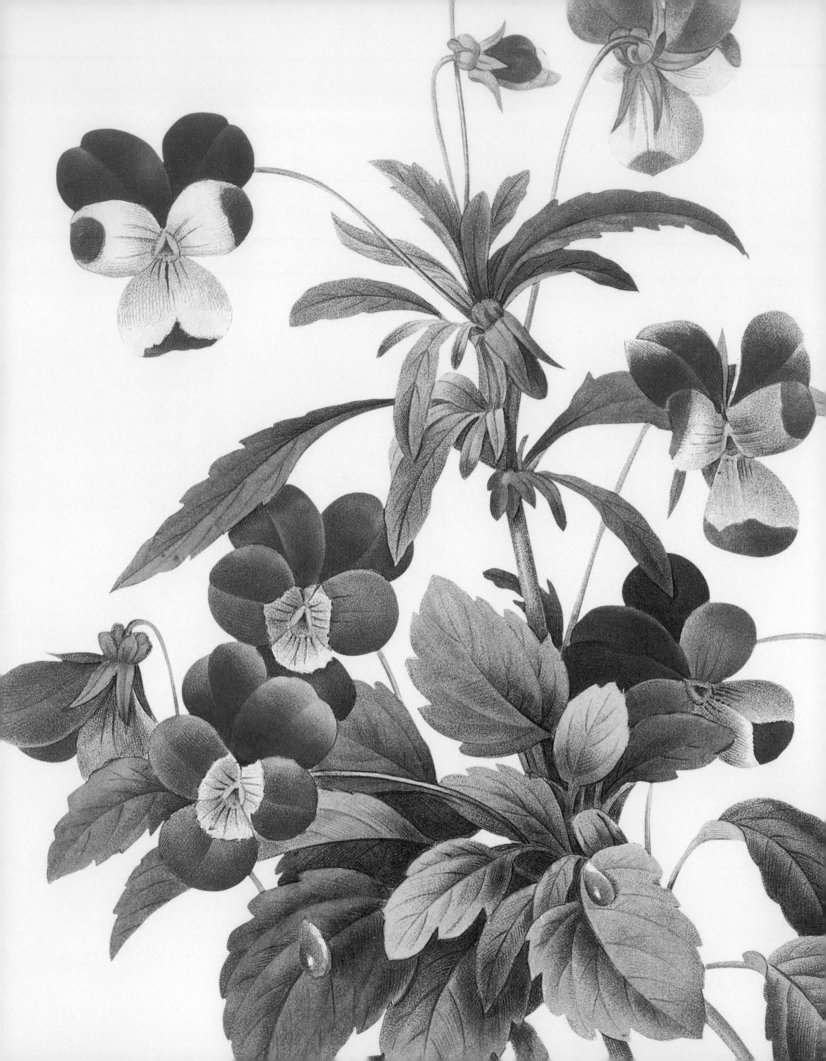

CHAPTER 12

YELLOW AND VIOLET PANSIES
(COPYING A REDOUTÉ WATERCOLOUR)

Pansies may seem difficult to paint due to the intensity of their colour, which appears to be painted in only one application. I advise you, however, to begin with two or even three applications. This will simplify the process, especially for the violet petals. The trick is to prepare a mixture that is very concentrated in pigment. If you like, use the drawing of pansies on page 183.

COLOURS:

New gamboge, saffron yellow, cobalt blue, Prussian blue, neutral shade, sepia and indigo.

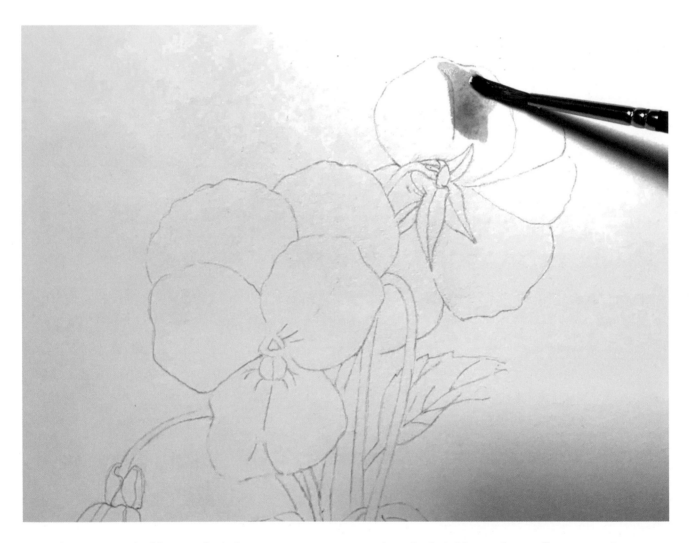

Begin by painting the blue petals with a mixture containing a lot of cobalt blue and a small amount of carmine.

Paint the violet petals with a concentrated mixture of cobalt blue with more carmine than you used in the first tone. Allow it to dry.

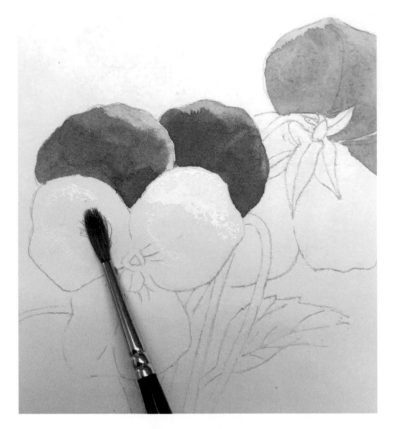

Paint the yellow petals with new gamboge diluted with a lot of water. Allow it to dry.

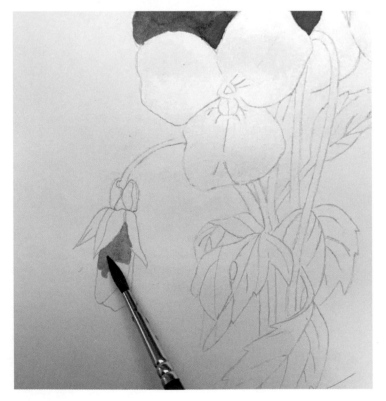

Paint the bud with the same violet mixture as above, with an added touch of indigo.

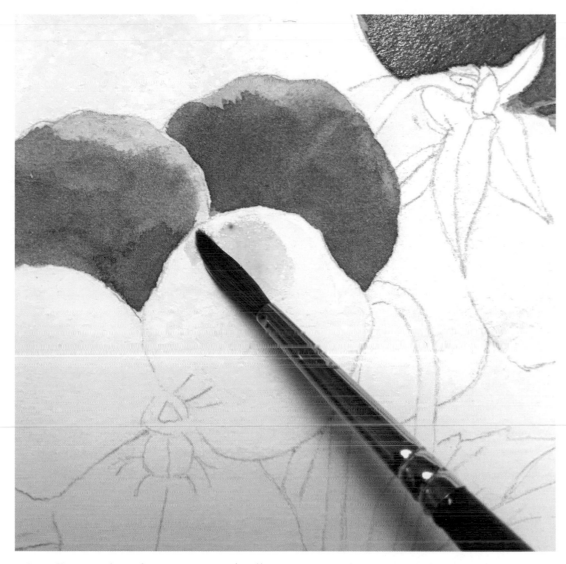

Reinforce the yellow petals with a concentrated saffron mixture, which will add brightness.

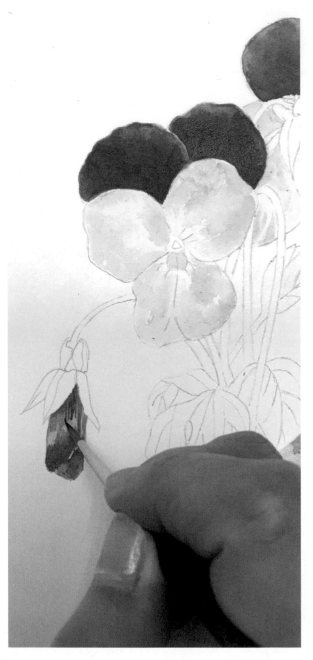

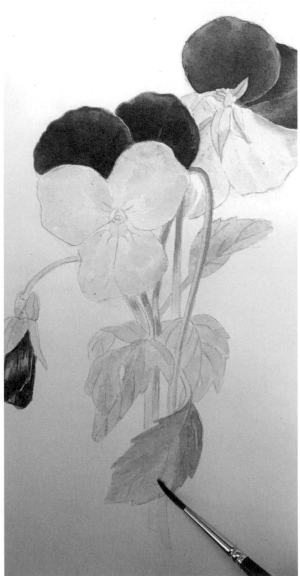

Use a wash of the violet mixture on the upper petals to deepen the colour.

Paint the details of the bud with the same mixture. Intensify the shadows with little strokes and crosshatching with the neutral tint.

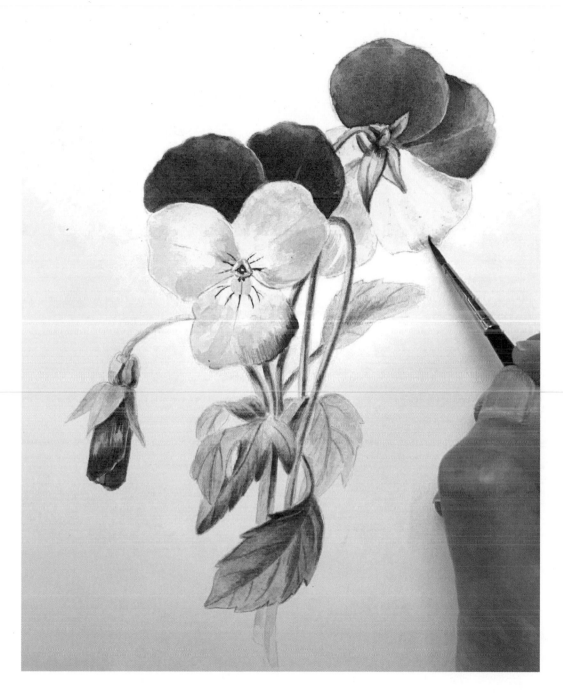

After painting the leaves with the basic green mixture, add details with small strokes and add shadows with a darker green mixture. Add finishing details to the yellow petals of the flowers with violet, neutral tint and sepia for the shadow, using small crosshatching. Add small strokes of sepia and neutral tint to the centre of the flower.

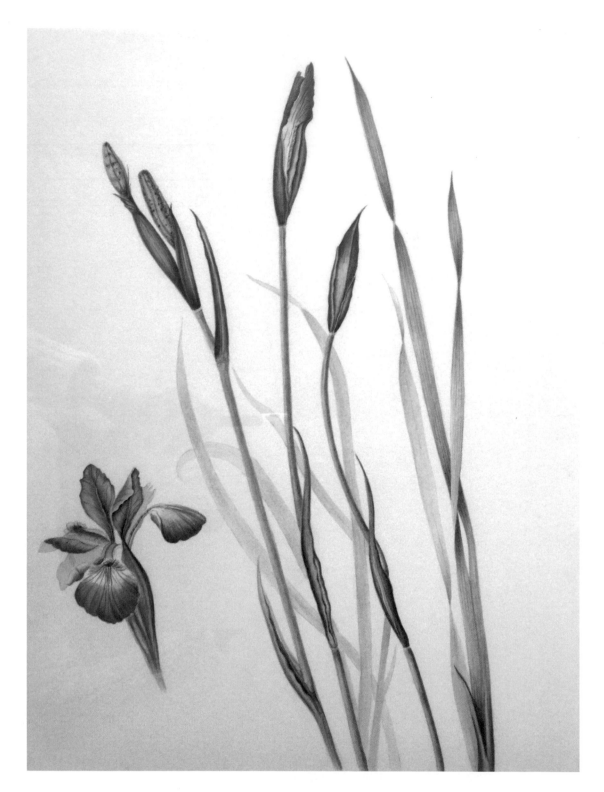

IRIS
Watercolour on Arches paper, 57 x 38.5cm

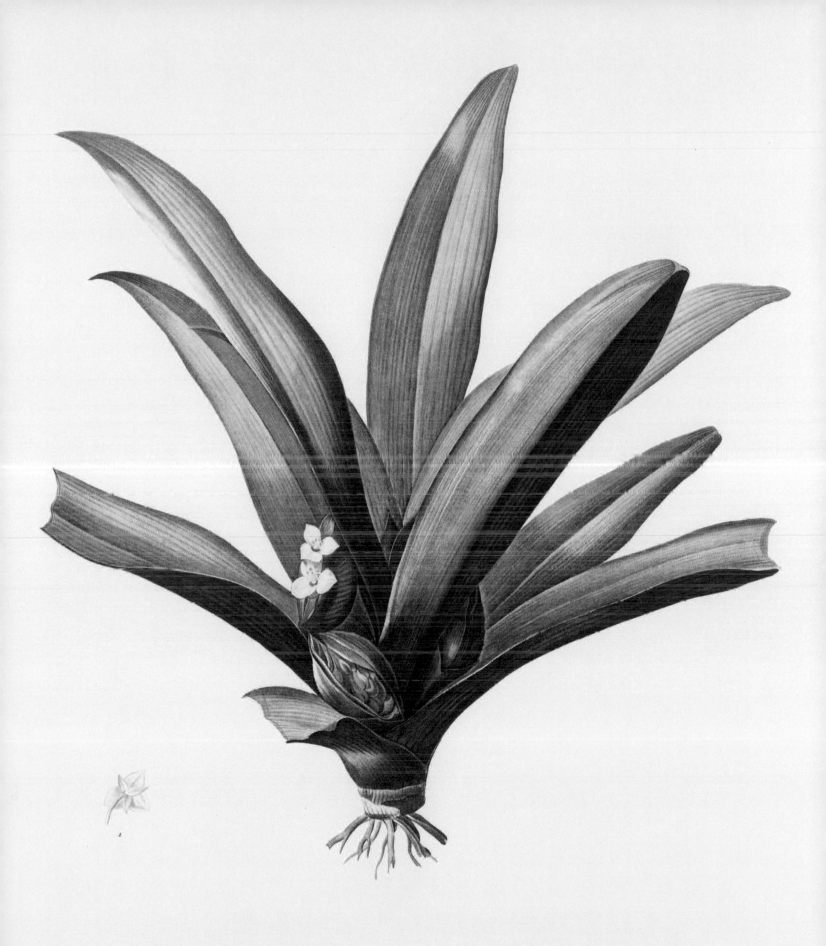

Tradescantia Discolor *Ephemere Discolore*

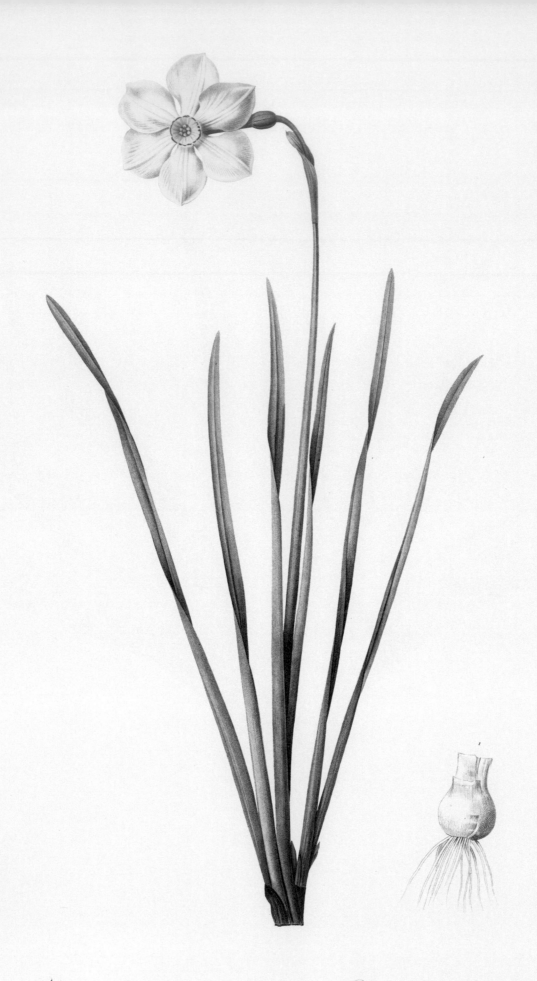

Narcissus Poeticus *Narcisse des Poëtes*

CHAPTER 13

WHITE FLOWERS: NARCISSI
(COPYING A WATERCOLOUR BY ANTOINE PASCAL)

COLOURS:

New gamboge, Indian yellow, saffron, cobalt blue, Prussian blue and neutral shade. You will find a drawing of a narcissus on page 184.

Painting white flowers can be a little delicate with Redouté's method. But with a little practice, the difficulties are quickly overcome. Begin with a methodical approach; spontaneity will soon follow.

Prepare a slightly greenish-grey mixture of cobalt blue, neutral tint, a tiny amount of Prussian blue and new gamboge. There are many ways to obtain a green-tinted grey: one could use either a mixture of cobalt blue and natural sienna or one of indigo, new gamboge and sepia (the latter mixture, however, is more challenging to get right, because indigo is a concentrated pigment). If you have trouble getting the right shade of greenish-grey, you can use Winsor & Newton's Davy Gray or an equivalent shade. Then prepare a very diluted Indian yellow for the nectar of the flower and a more concentrated mixture of carmine and saffron for the fine border of the nectar.

Begin by painting the lower petal with the grey mixture, starting at the centre to capture the shadows on the petal as well as those on the edge, coming from the other petals.

Continue to paint the rest of the petals in the same manner.

Paint the corona with Indian yellow.

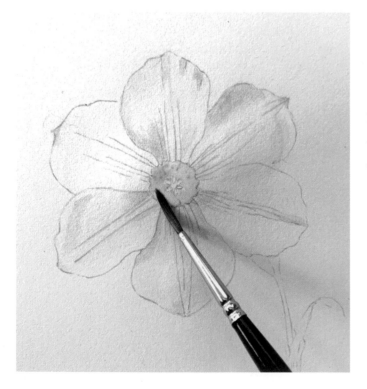

Paint the darker parts of the interior of the corona with Indian yellow and a touch of the grey mixture you used on the petals.

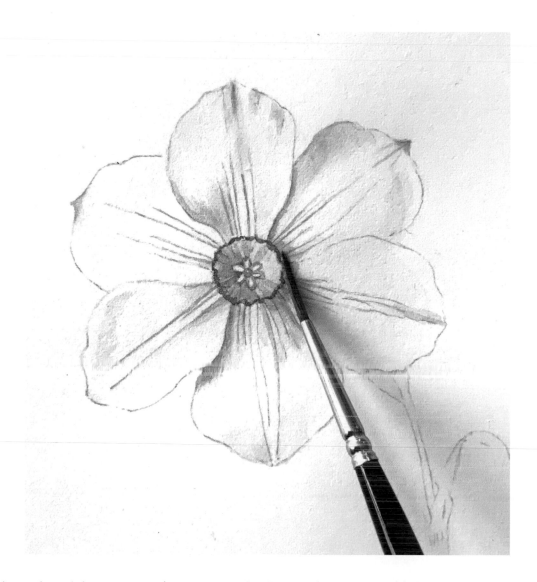

Paint the lacy edge of the corona with a mixture of saffron and carmine. Add the finishing touches with the same grey. Proceed with a light drawing of lines on the petals.

Paint the yellow hue at the base of the petals with a very diluted new gamboge. Intensify the shadows to add depth – particularly in the drop shadows of the petals. Avoid overdoing the shadows, or the flowers will appear artificial and lack lightness and grace. Allow it to dry.

Remove pencil marks that appear too heavy with a very soft eraser.

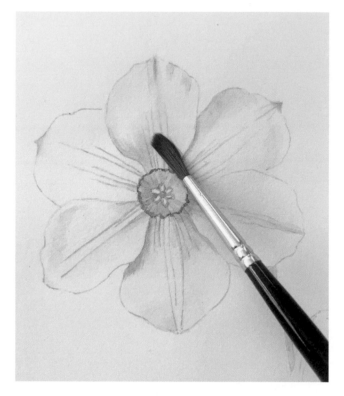

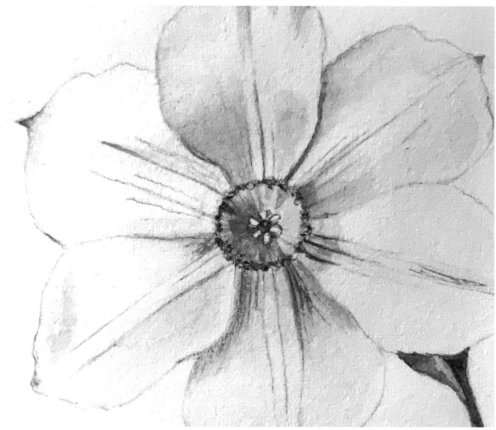

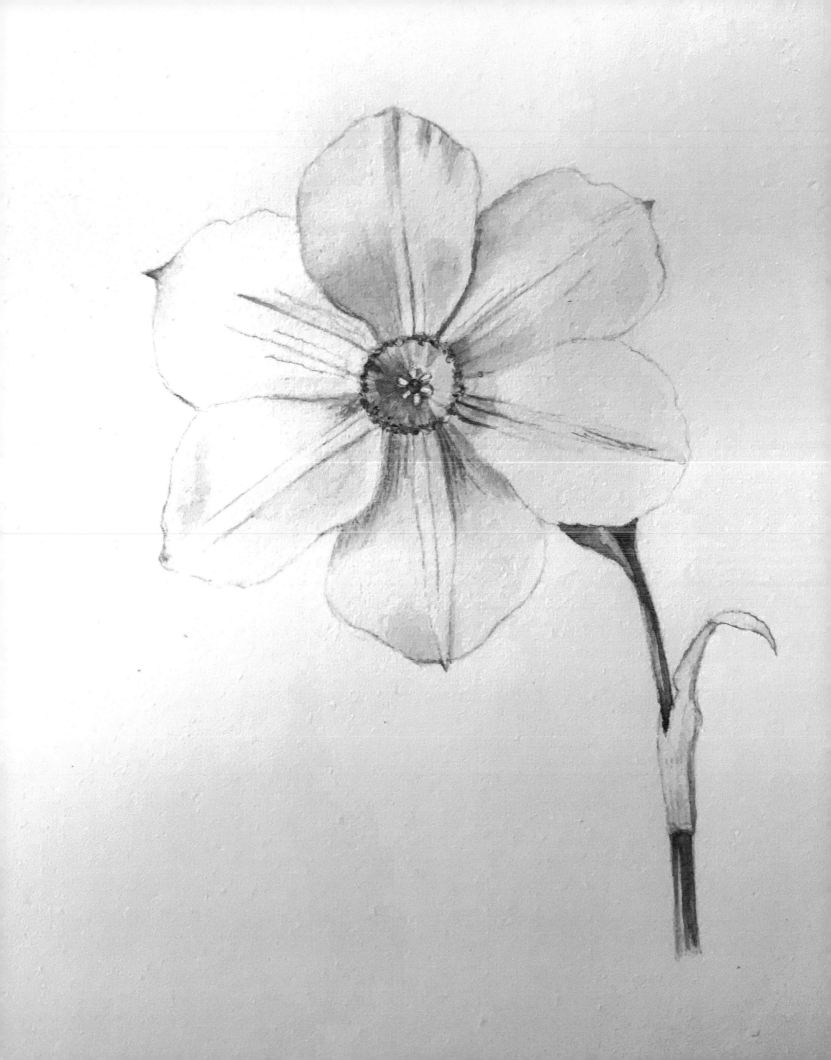

To emphasise white or very pale flowers, play with contrasts by painting them in front of foliage. The flowers will be more visible against a darker background.

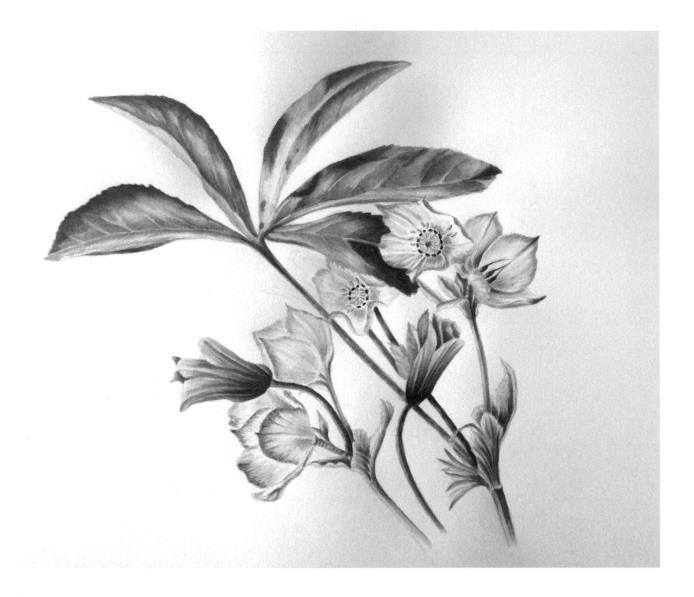

HELLEBORES

Watercolour on Arches paper, 49 x 39cm

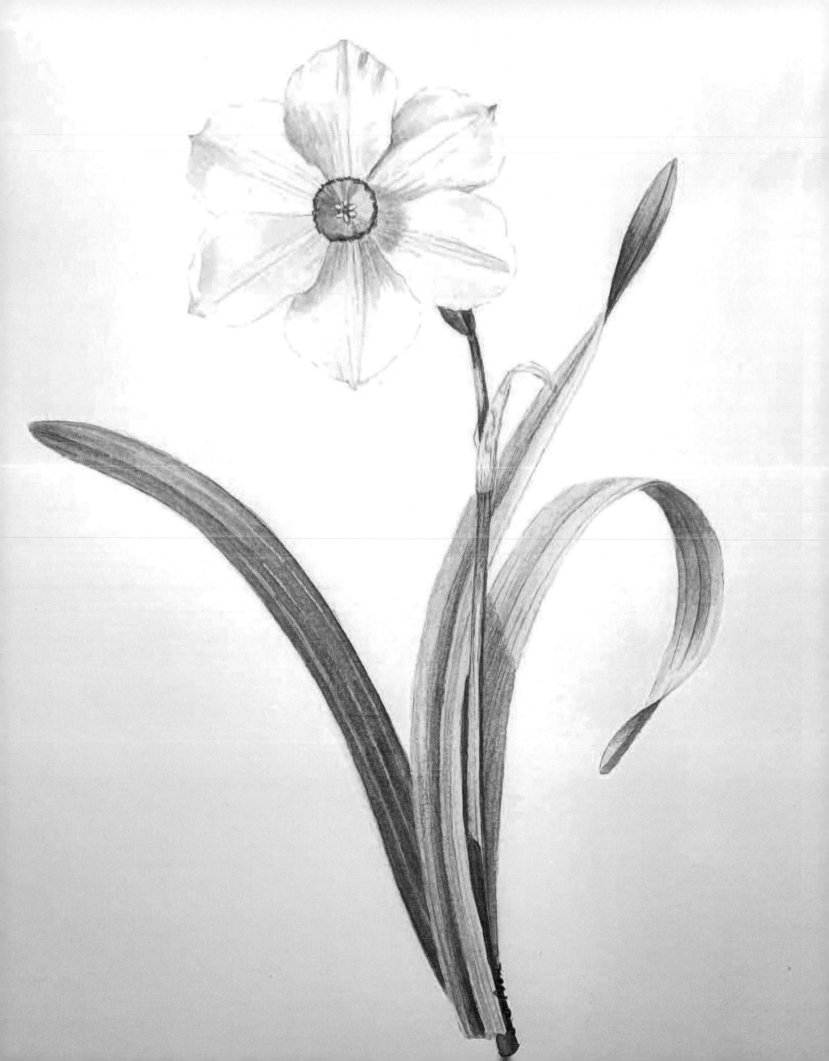

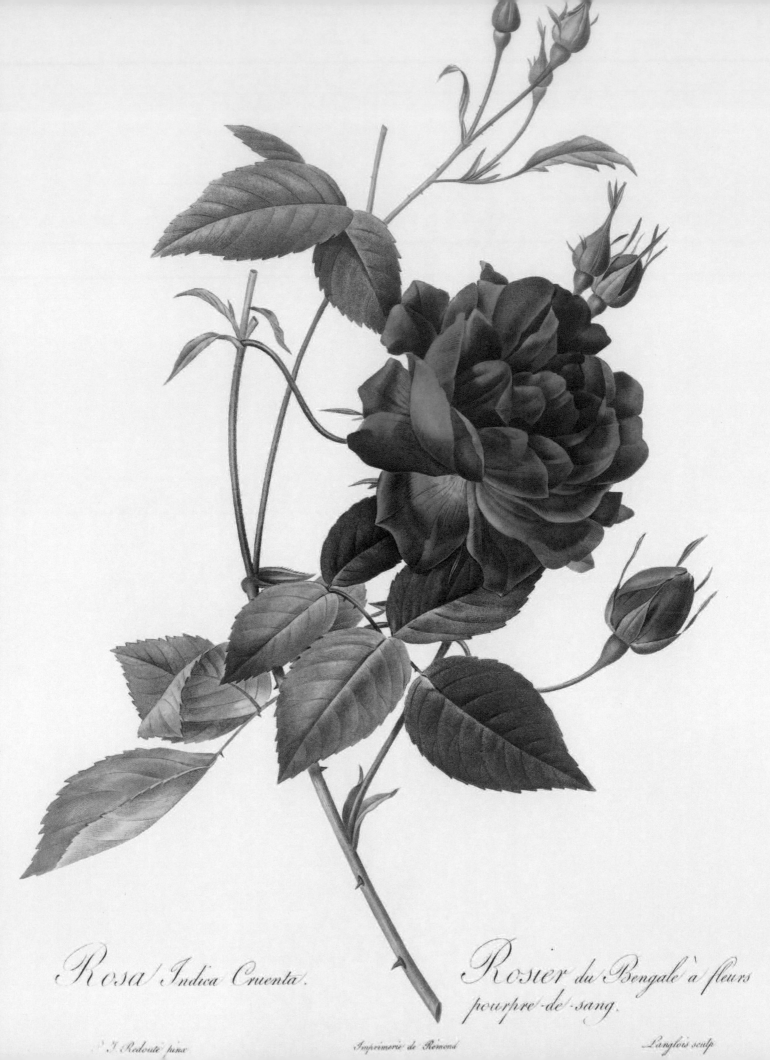

Rosa Indica Cruenta.

Rosier du Bengale à fleurs pourpre-de-sang.

P. J. Redouté pinx Imprimerie de Rémond Langlois sculp

CHAPTER 14

RED FLOWERS: ROSES
(COPYING A REDOUTÉ WATERCOLOUR)

COLOURS:

To paint this bright red flower, you will need to prepare the saffron pigment (*see* page 158). Then add carmine to obtain a warm and bright vermilion mixture.

The rose drawing is on page 185. Start by applying an orange-tinted wash made from saffron and a little carmine. Allow it to dry.

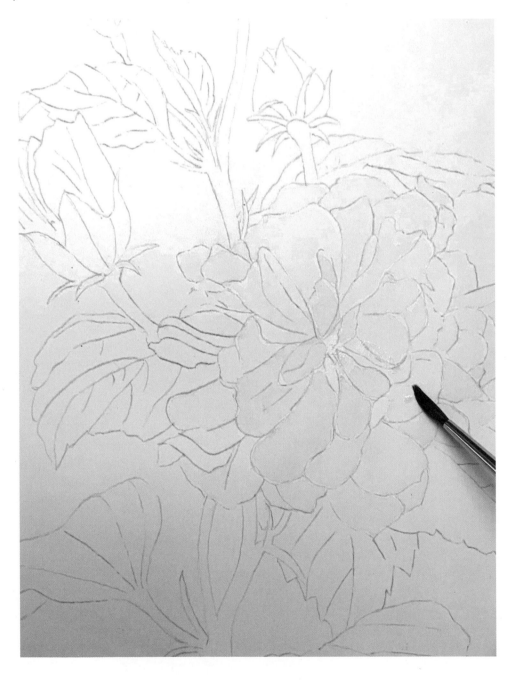

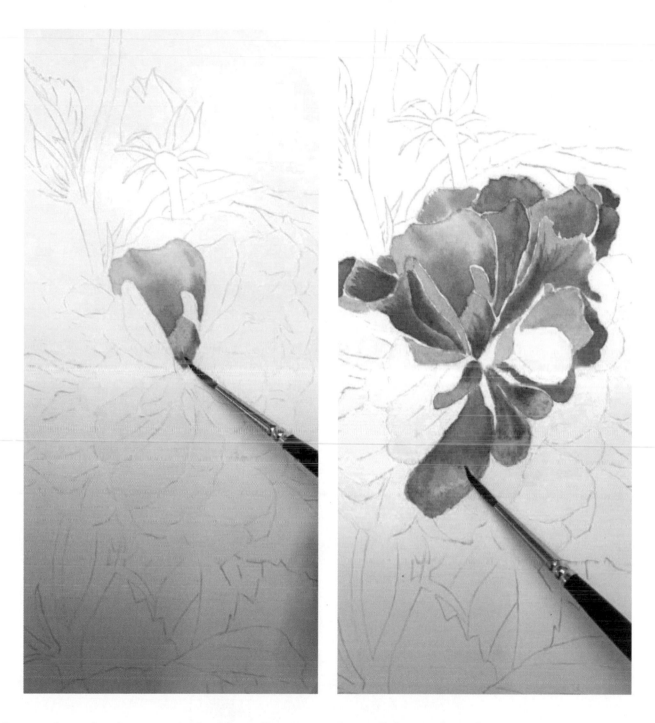

Paint each petal with two tones of red (a small amount of saffron and carmine) prepared in large quantities. The first tone should be quite strong pigment-wise and the second should be stronger still, with even more carmine added to it.

Paint all the petals in the same manner, taking into account highlights and shadows. Leave a very fine unpainted border between the petals.

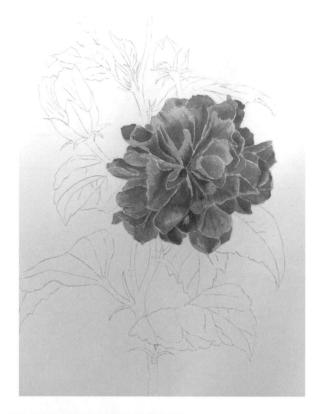

Allow the finished flower to dry, and then place a very diluted saffron wash over the entire bloom, covering the unpainted border. This adds softness and brightness.

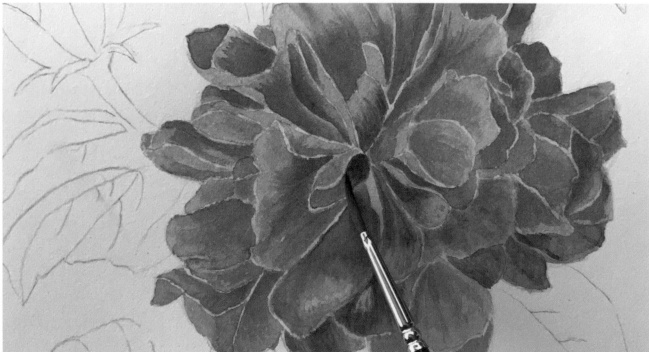

Add details, deepening the shadows with small strokes and crosshatching with a mixture of carmine and a touch of sepia.

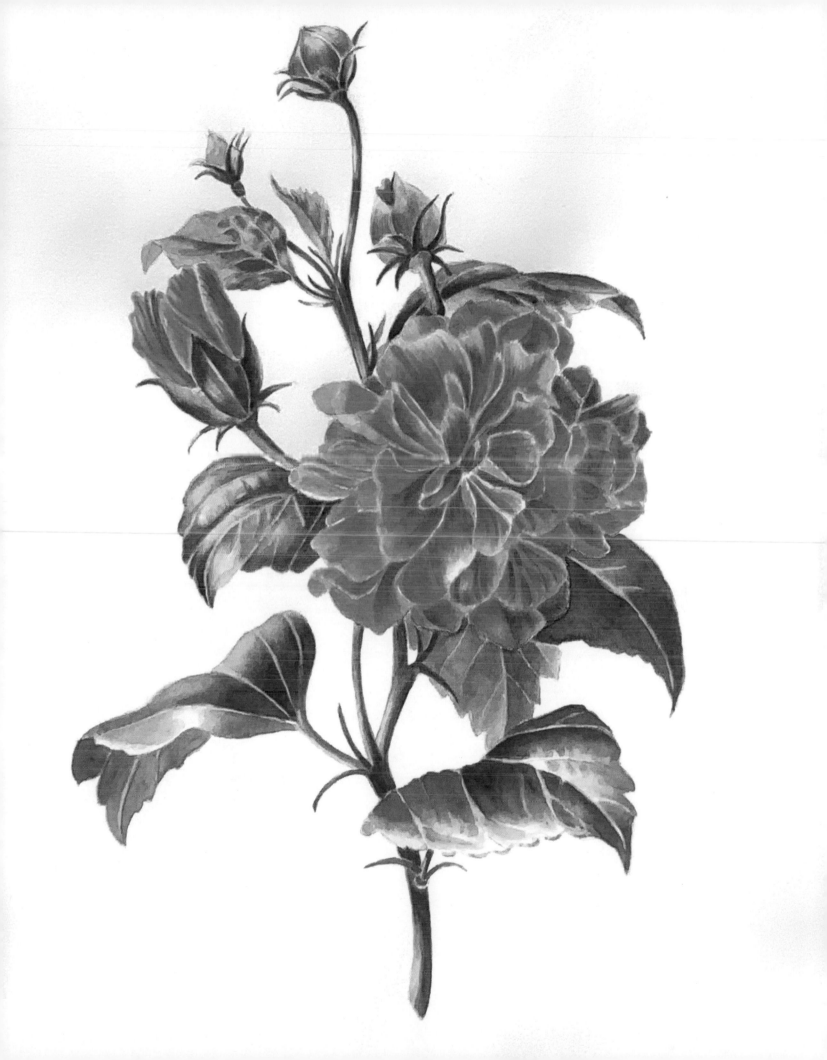

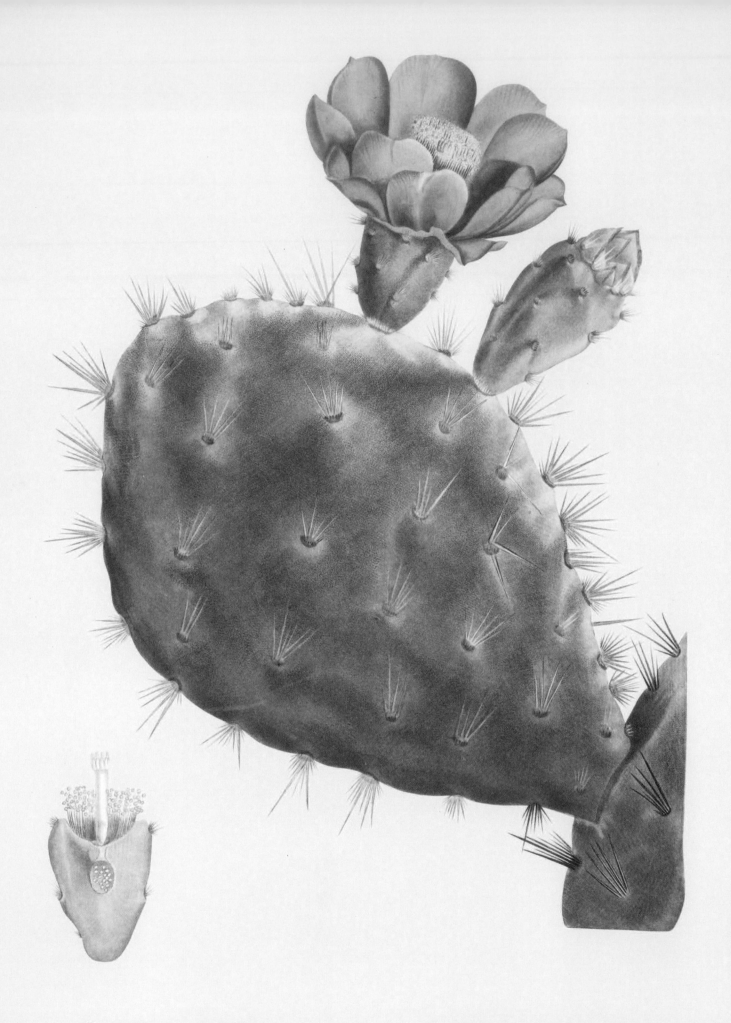

CACTUS cochenillifer. CIERGE à cochenille.

CHAPTER 15

CACTUS FLOWER ON VELLUM

Painting on vellum represents a challenge, as vellum does not absorb a lot of water. The sketch should be done in the same manner as with watercolour paper, but avoid using very diluted glazes on the petals and stems, as they could efface the underlying colours. Any errors are easier to correct on vellum than on paper. Use a brush that is barely wet, then delicately apply the paint directly onto the vellum. Then let it dry.

Transfer the drawing on page 186 onto the vellum with tracing paper. The vellum used here is 24 x 18cm. A good supplier of artists' materials should be able to obtain vellum for you if they don't stock it

COLOURS:

New gamboge, Indian yellow, saffron, carmine, Prussian blue, cobalt blue, sepia and a little white gouache.

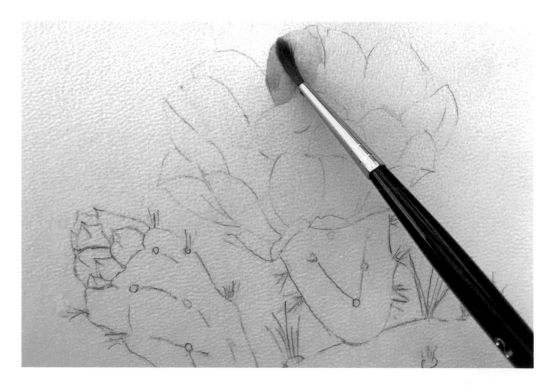

Begin by painting the pink flower with a mixture of carmine and a tiny amount of saffron. The second mixture is only carmine, but uses more pigment. The darker tone is a mixture of carmine with a little saffron and sepia. After this step but before adding the finishing touches, if a petal appears too pale in places, paint it again with the carmine mixture. Let the paint mixtures flow. Do not rub the vellum, or it will remove the underlying colour. If this happens remove the paint, let the vellum dry, and start again.

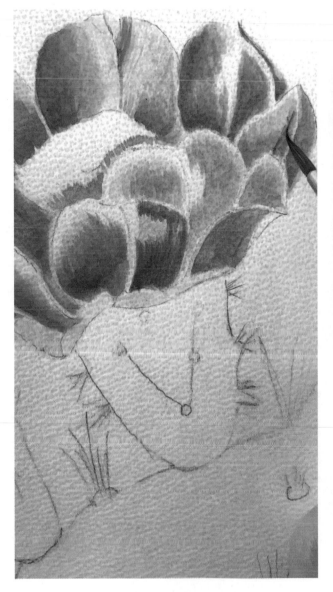

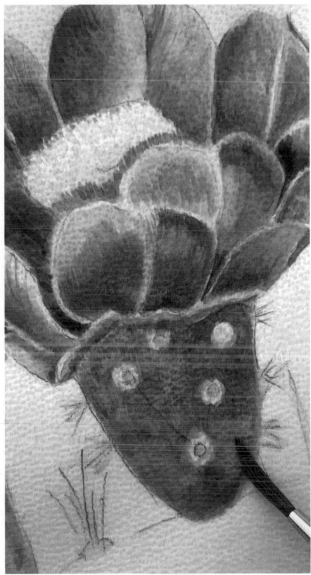

Begin the finishing touches with carmine. In the shaded areas, add small strokes and crosshatching with a mixture of carmine, saffron and sepia. Hold the brush upright to work with the point.

The stamens are painted with Indian yellow. Prepare the first green tone with new gamboge, Prussian blue, cobalt blue and a touch of sepia; make a second tone by combining the first mixture with more sepia. Paint the stem with the first green mixture and use the second mixture for the darker shadows. Take care to leave unpainted white circles, which are the areoles. Allow the paint to dry. Then paint the centres of the areoles with new gamboge.

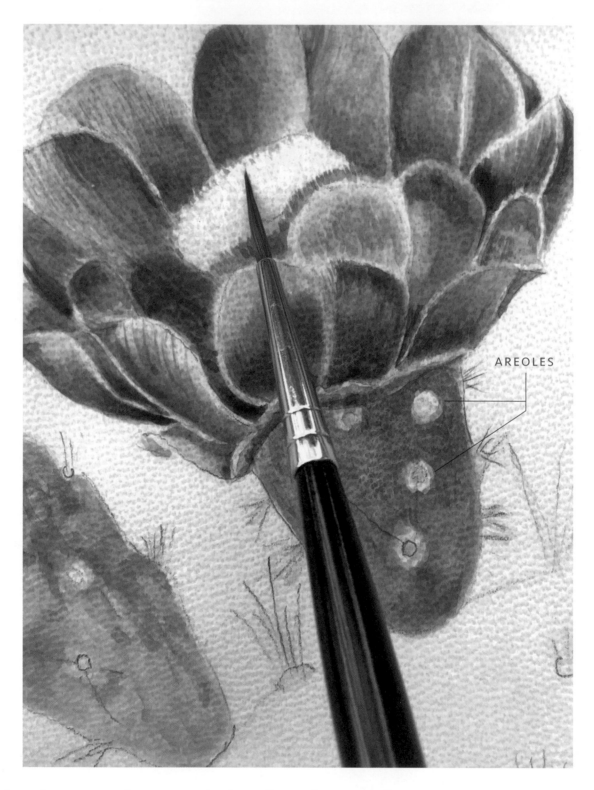

Reinforce the stamens with a mixture of Indian yellow and sepia. Gently erase the pencil marks on the drawing with a very soft eraser.

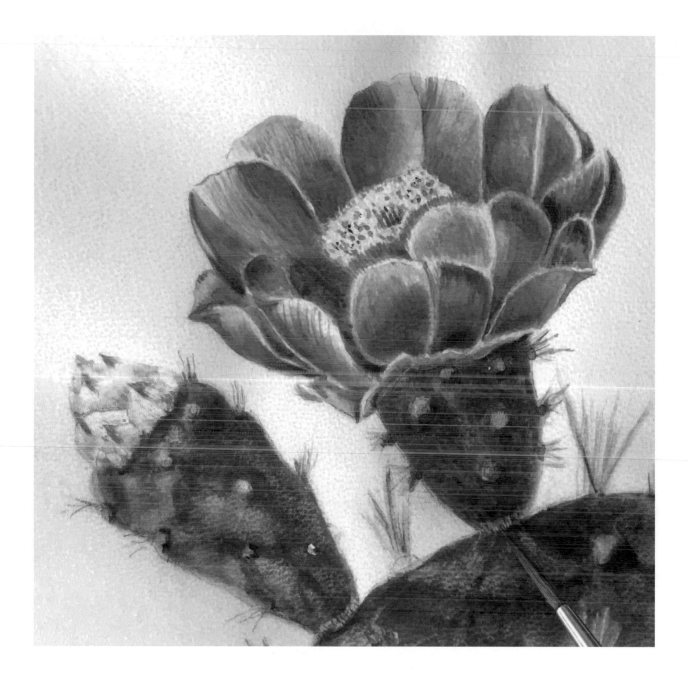

– FINISHING TOUCHES –

Paint the pistil in the centre of the stamens with the green tone. Add a few small dots of green and sepia in the stamens. Respecting the different sizes and orientations, paint the spines with a mix of sepia and carmine. Darken the stems with small strokes of a darker shade of green made from new gamboge, Prussian blue and indigo. The contrasts are very sharp; the thick stems must be distinguishable and compact. The bud to the left is painted in the same way. Finally, small strokes of white gouache can be added to capture the highlights.

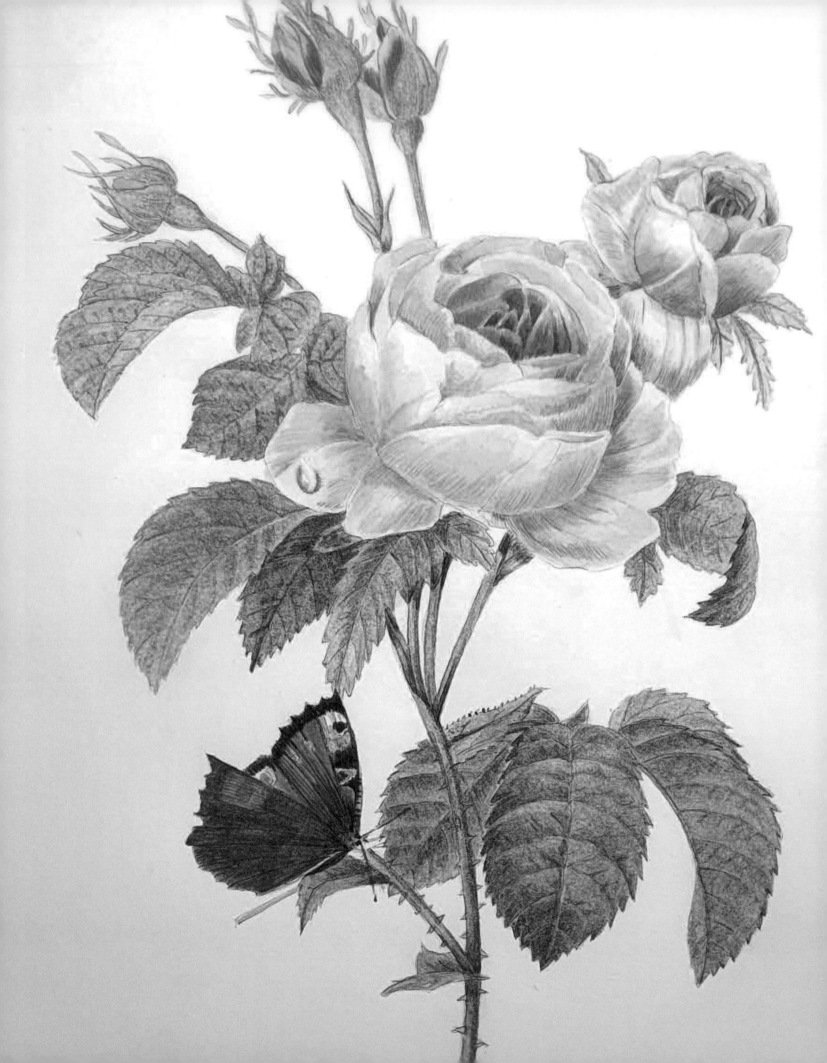

CHAPTER 16

BUTTERFLIES
AND DROPS OF WATER

— BUTTERFLIES —

Following a tradition from the 17th century, Redouté often included butterflies, bees and flies in his oil paintings of bouquets, which added to the realism of the painting. In his watercolours, butterflies were sometimes included to mask errors that occurred while painting. The challenge is to give a light, soft and powdery texture to the body of the butterfly, creating contrast without heaviness or using gouache.

At the beginning of the 19th century, the 'language' of flowers was used to convey emotional and affectionate messages.

YELLOW BUTTERFLY PAINTED ON VELLUM, FIRST TECHNIQUE

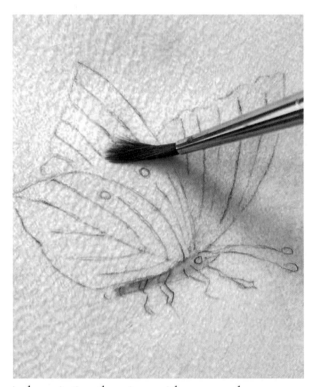

Begin by painting the wings with new gamboge.

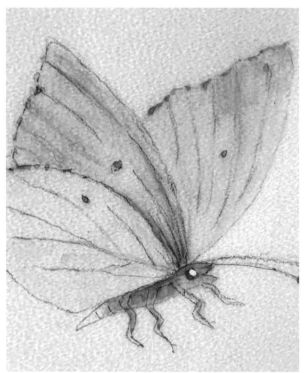

Finishing touches are painted with a mixture of carmine and burnt umber for the spots and body. After the paint dries, add a dot of white gouache for the eye.

ORANGE BUTTERFLY PAINTED ON VELLUM, SECOND TECHNIQUE

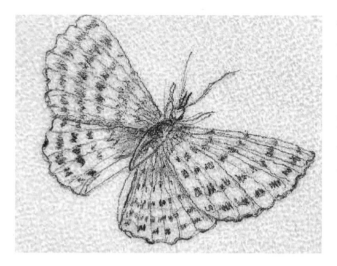

The drawing is very detailed; the shadows have been achieved by using the soft pencil (B/#2), which emphasises the contrast of the markings.

Paint the insect with a mixture of saffron and carmine; then add the darker parts with some burnt sienna added to the first mixture.

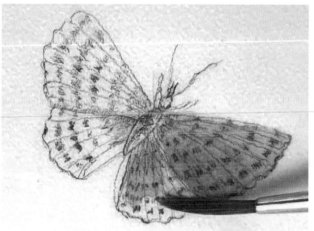

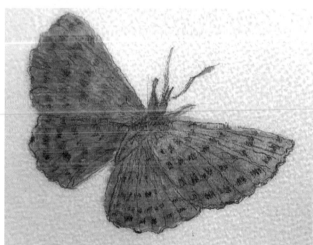

For the very brown parts, add small strokes of sepia.

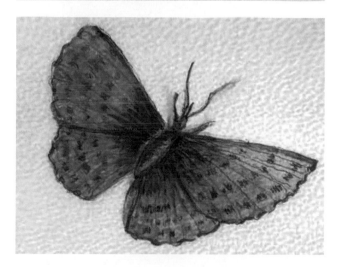

— WATER DROPS —

A drop of water is often present on a petal or leaf; this helps to reinforce the realism of the painting. For the sketch, we will use the colour of the part where the drop is located.

For a leaf: Draw the droplet using the hard pencil (H/#1), and then paint it with the green tone, leaving a small spot blank for the light effect.

For a rose-coloured petal: Draw as above, then fill with diluted carmine, leaving a small spot unpainted.

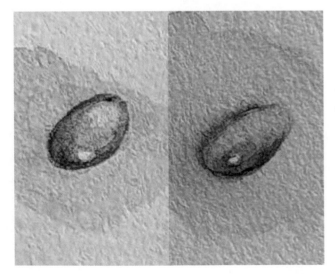

Add details to the leaf droplet by using a darker green with a touch of indigo. For the rose-coloured droplet, use a mixture of carmine and cobalt blue, with small strokes to add emphasis. If the white highlight has disappeared, add a touch of gouache.

— PAINTINGS BY THE AUTHOR —

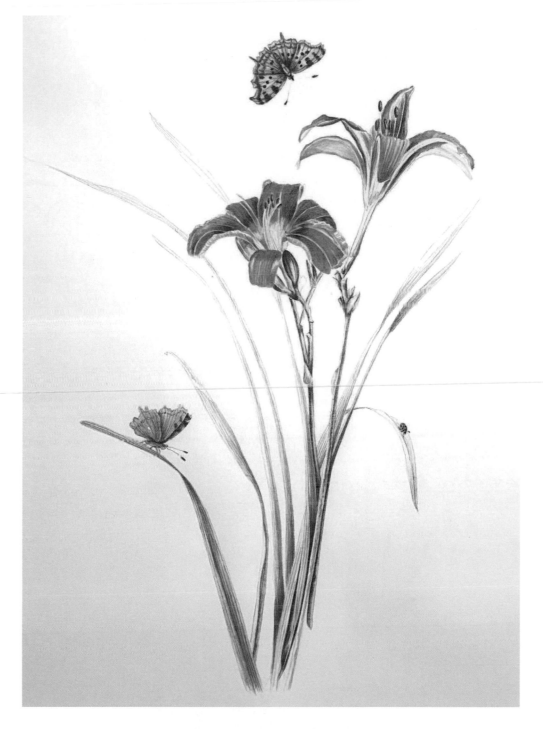

ORANGE IRIS WITH BUTTERFLY

Watercolour on Arches paper, 49 x 39cm

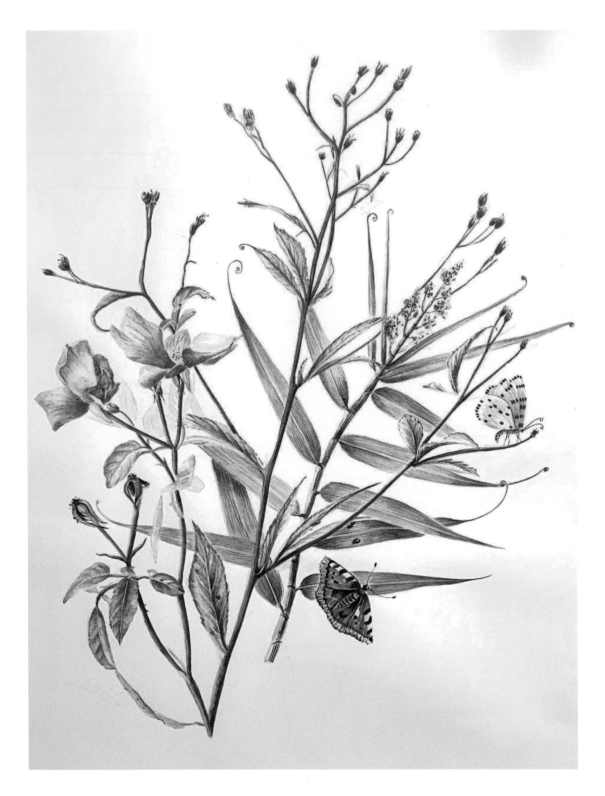

SMALL ROSES AND GRASSES
Watercolour on Arches paper 57 x 38.5cm

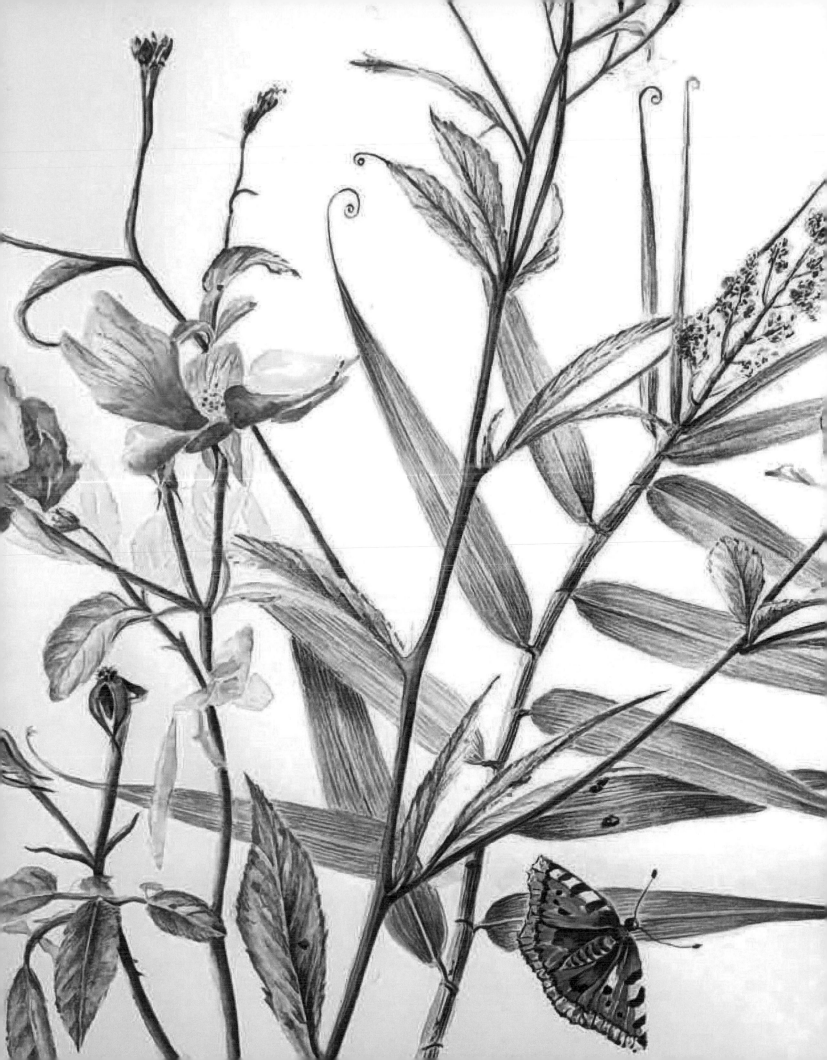

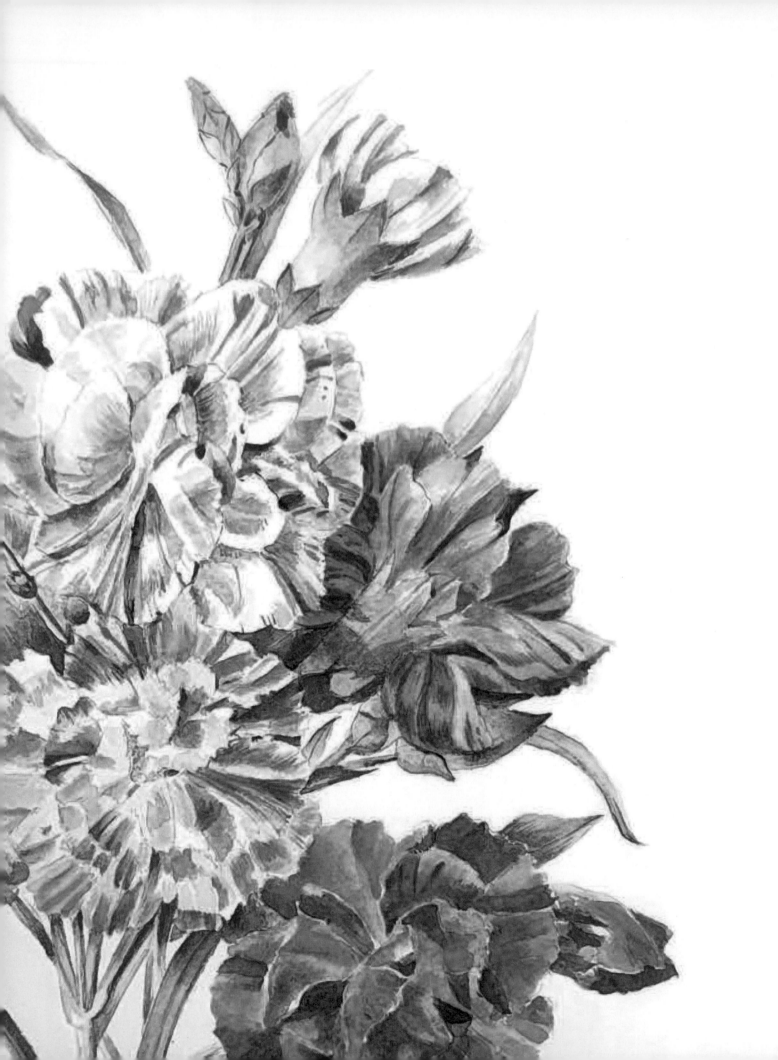

CHAPTER 17

BOUQUETS

This bouquet contains many brightly coloured flowers. It will be an excellent exercise in practising what you have learned and discovering the composition of Redouté's later works. Please feel free to use the bouquet drawing on page 187. I suggest that you refer to the numbered instructions before beginning.

Details of the colours:

WHITE CARNATION

The grey is a mixture of cobalt blue and raw sienna ①, carmine ② and then a mixture of carmine and cobalt blue ③.

YELLOW CARNATION ON THE LEFT

Very diluted new gamboge ④, green composed of new gamboge and Prussian blue ⑤, grey made of cobalt blue and raw sienna ⑥.

YELLOW-ORANGE CARNATION IN THE CENTRE

Very diluted new gamboge ⑦, orange made from saffron and carmine ⑧, carmine ⑨, and carmine and sepia ⑩.

RED CARNATION, TOP RIGHT

A mixture of saffron and carmine ⑪, then the same mixture with added sepia ⑫.

RED ROSE, BOTTOM RIGHT

Carmine ⑬, violet made from cobalt blue and carmine ⑭, and finally carmine with a touch of sepia ⑮.

STEMS, LEAVES AND BUDS

After placing a glaze of very diluted new gamboge in the lightest parts ⑯, paint with a cooler green made from Prussian blue and new gamboge ⑰. Add the shadows with small strokes and crosshatching, using this mixture with an added touch of indigo.

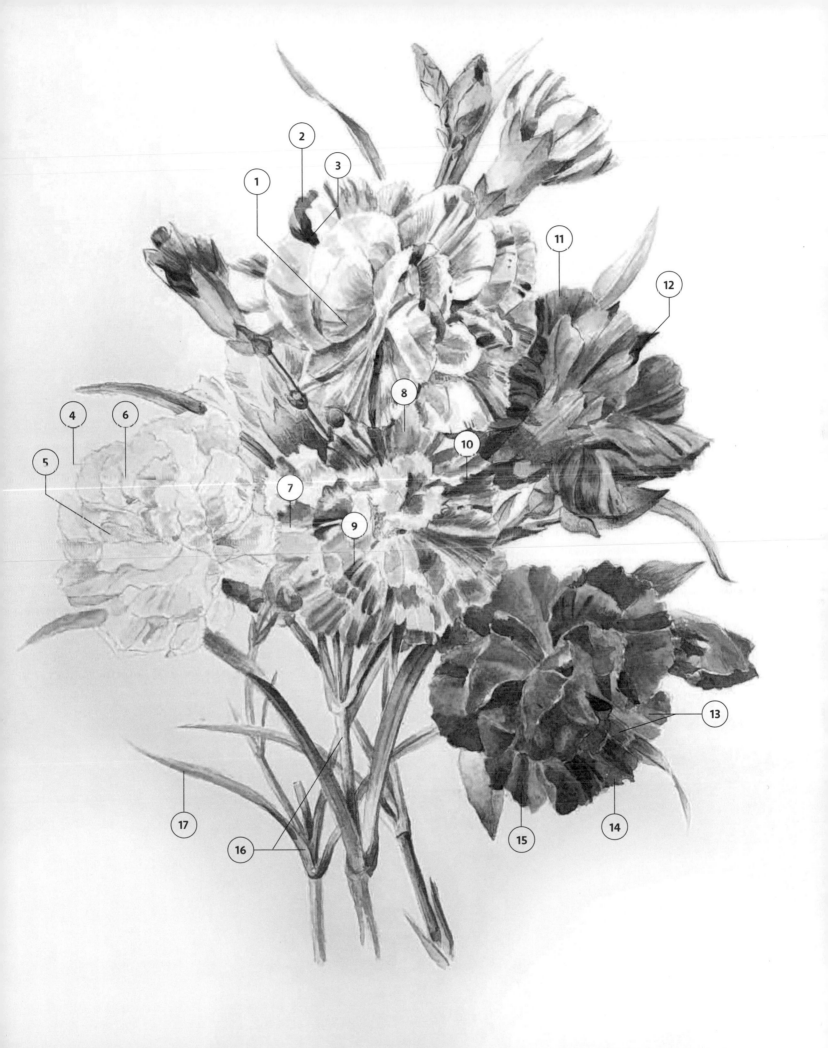

CHAPTER 18

SOME OBSERVATIONS AND ADDITIONAL TECHNIQUES
FOR CREATING BOTANICAL PLATES

PREPARING SAFFRON WATERCOLOUR

In Redouté's time, saffron-hued watercolour was prepared according to a recipe included in Étienne Huard's book *The Art of Painting Flowers with Watercolors and Coloring Engravings Without a Master*, published in 1839: 'Infuse the saffron pistils for 12 hours in a small amount of clear, cold water. Then strain the mixture through a clean cloth into a cup to recover the colouring agent.'

I propose the following recipe for preparing your watercolours from scratch: for one measure of dry pigment, add one measure of gum Arabic, ⅓ measure of glycerine, and a drop of preservative. These ingredients can be purchased online and at art-supply shops.

THE FRAME: SHELL GOLD

Traditionally, watercolour paintings on vellum were framed by a thin line of gold. Redouté often painted a leaf, petal, stem or bud beyond the gold frame to create an unexpected and original effect – as if nature were taking back its rights and escaping the rigid confines of the frame. Redouté progressively abandoned the frame altogether to have more freedom in his compositions.

Shell gold is a mixture of gold powder with gum Arabic. After drawing the frame, use a brush to apply the gold. Once it has dried, polish it with the tip of an agate stone to make it shine. These ingredients can be purchased online and at art-supply shops.

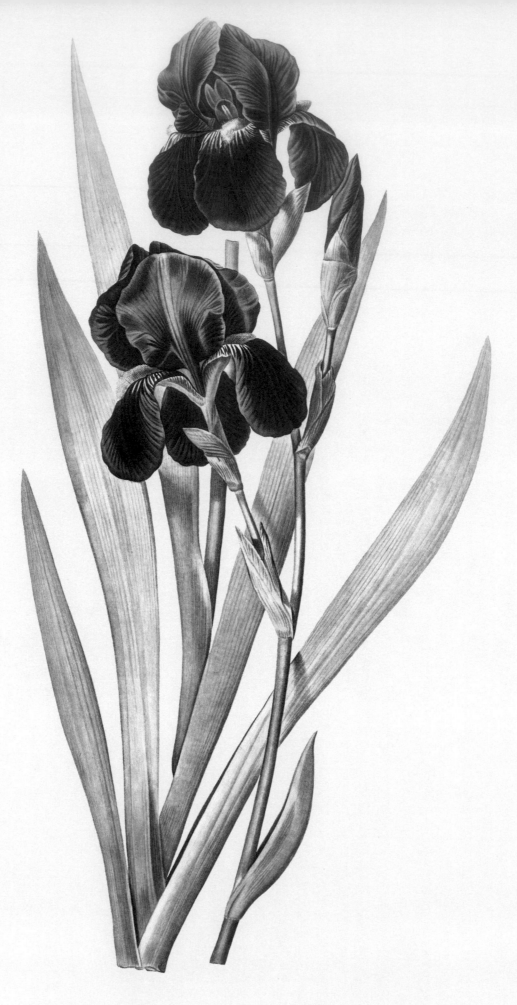

Iris Germanica *Iris Germanique*

LETTERING AND CALLIGRAPHY

The elegant cursive English script that was often used by Pierre-Joseph Redouté is suitable for botanical plates. Its strokes are of different thicknesses, with ornate capital letters that work beautifully with botanical paintings.

Thick strokes are made by moving downward with a fountain pen; slender strokes are achieved by moving the pen upward; and the angle of the letters must be kept at 50°. It is a good idea to practise calligraphy, and for that I recommend Jacques Herbin's classic *Cahier d'exercices d'écriture anglaise* (*Calligraphy Exercise Book*), but there are many good books on calligraphy available that explain how to produce a classic script. Make sure you use a fountain pen made specifically for calligraphy, and black ink.

It is important to harmonise the calligraphy with the painting. The writing must not be too dark or contrasting, or it will draw the eye away from the plant or flowers. Practise frequently, diluting the ink with water if necessary or adding a tiny amount of sepia before actually writing on the painting.

In order to determine the best place for the writing, it is best to use tracing paper and then transfer the lettering onto the painting. The name of the flower – both the vernacular and the Latin terms – is situated at the bottom of the painting.

CHAPTER 19

SOME OBSERVATIONS ON
PERSPECTIVE AND COMPOSITION

Composition in painting is the organisation of shapes in an image – the presentation of one or more flowers to create an ensemble. We strive for harmony. A single flower may be presented with its leaves and be pleasing to the eye, as observed in the painting of the yellow rose in Chapter 9.

Usually, a white border is left around the plant. The conventional presentation is with the flower or plants in the centre of the painting with the white border forming a frame for the watercolour. Traditionally, vellums contained an outline in gold, with the name of the plant in calligraphy at the bottom. Pierre-Joseph Redouté progressively abandoned this practice to give free rein to the composition of the plants.

Artists should ask themselves a number of questions when deciding on a composition: does the whole provide a simple and geometric form, such as a triangle, circle or square? Is it well-balanced?

Painters should add variety to the composition of plants to avoid too much symmetry; flowers may be displayed at different angles. Try to discover different effects, to avoid monotony.

Try an original layout by perhaps abandoning the usual vertical compositional format in favour of a horizontal one and adapting it to the natural development of the flower.

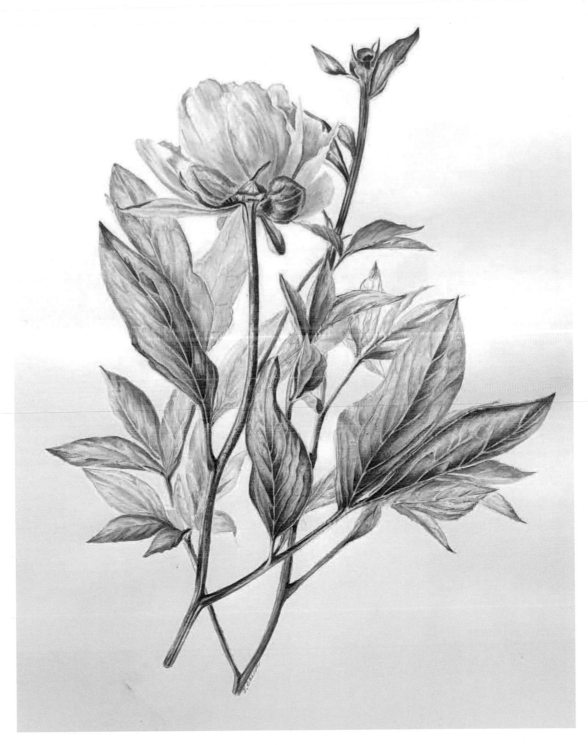

PEONY

Watercolour on Arches paper, 57 x 38.5cm

PEONY

Watercolour on Arches paper, 57 x 38.5cm

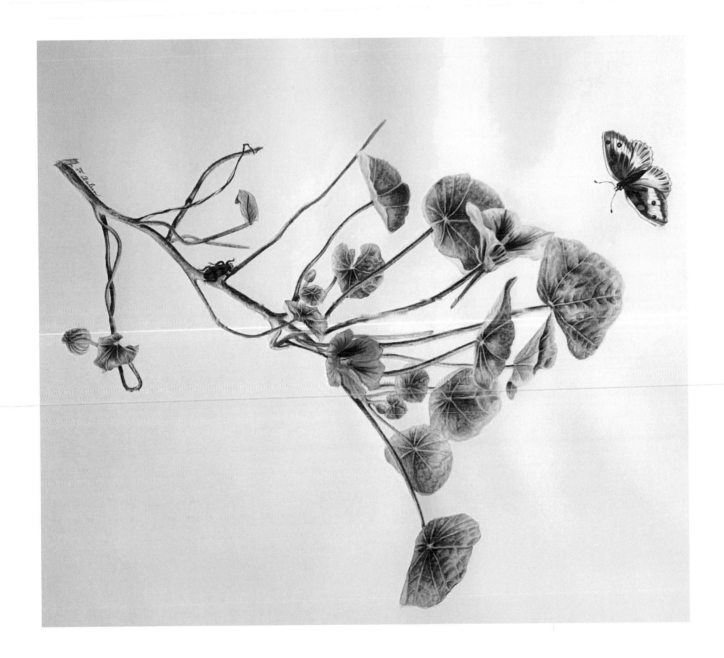

NASTURTIUM

Watercolour on Arches paper, 57 x 38.5cm

Starting with an ambitious composition of several flowers, you can select a few flowers to create a different painting, as illustrated in the following two paintings.

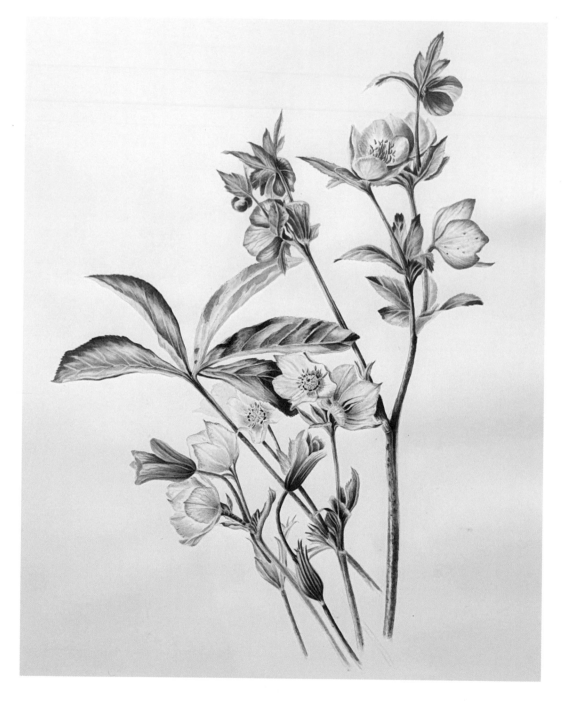

HELLEBORES
Watercolour on Arches paper, 57 x 38.5cm

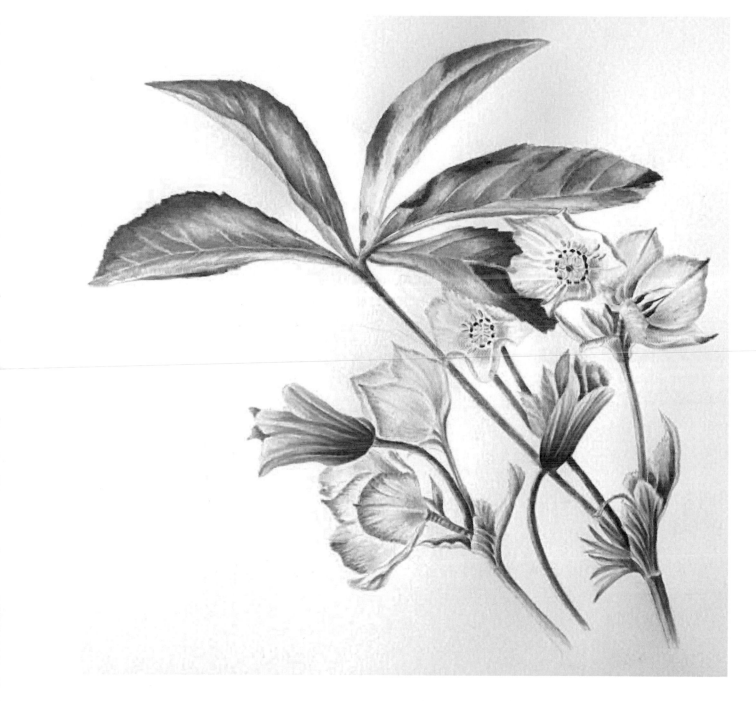

HELLEBORES

Watercolour on Arches paper, 49 x 39cm

We can develop an eye for composition and find inspiration by studying the botanical plates and oil paintings of the old masters: Nicolas Robert (1614–1685), Claude Aubriet (1665–1742), Georg Dionysius Ehret (1708–1742), the Bauer brothers (Ferdinand, Franz and Joseph), Gerard van Spaendonck (1746–1822), Ambrosius Bosschaert (1573–1621), Jan Brueghel the Elder (1568–1625), Jan Davidsz de Heem (1606–1684), and Jacobus van Huysum (1687–1740).

In the works of these artists, you can see the different techniques used to add depth to the contrasts that please the viewer's eye. White flowers are placed in the light, near pink or blue ones that will emphasise the contrast. Violet or dark-red blossoms are placed in the shaded areas. To bring in other colours, the artist can add butterflies or insects: as Antoine Pascal said, 'Painting is only an illusion of reality, what is real is not true to life.' (from *L'Aquarelle, ou les fleur paintes d'après òa méthode de* M. Redouté, Paris, 1837)

We can make a composition by arranging flowers on white paper and then taking a photograph (*see* the yellow rose on page 88) or by making several drawings of flowers in different arrangements. This was the preferred method of the great masters of botanical painting, who had many references and compositions in their sketchbooks.

Notice the use of the same yellow roses in the very different compositions on pages 93 and 188.

Using tracing paper allows you to visualise different compositions before transferring the drawing onto the watercolour paper.

Painters often have an affection for certain flowers, and use them frequently in their compositions. Redouté appreciated roses, but also camellias, daisies, and peonies – all of these are found in his compositions.

The leaves of white flowers should be used to add depth, and to distinguish the flowers from the paper.

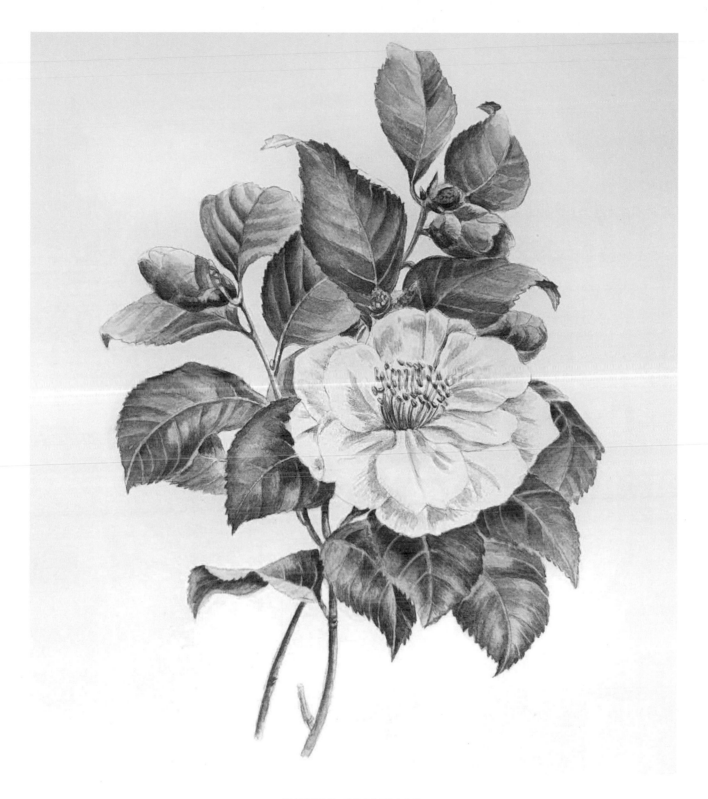

WHITE CAMELLIA

Copy of a watercolour on vellum by Pierre-Joseph Redouté, 30 x 22cm

You may need to impose a sense of three-dimensionality when it comes to the perspective: flowers in the background should be painted more lightly, and with less saturated colours. There should also be less detail; this will help bring depth to the whole. Look at the yellow rose on page 91 in Chapter 9 and notice the unfinished leaves in the upper left.

However, it's important to respect the proportions of plants: you shouldn't decide, for example, to lengthen the stem of a flower, particularly a small flower such as a pansy or violet.

Avoid any sense of stiffness or artificiality, such as having the stems meet in one place. Too much symmetry should also be avoided; arrange the flowers so that stems cross with leaves in different directions.

Inspiration can be found in the works of Nicolas Robert; he tied his bouquets with a ribbon as shown in the image to the right.

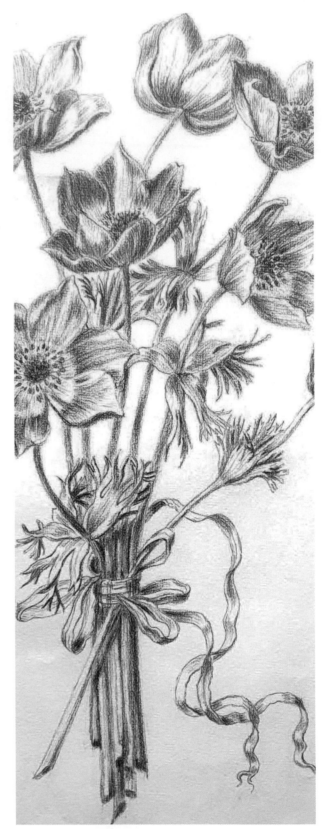

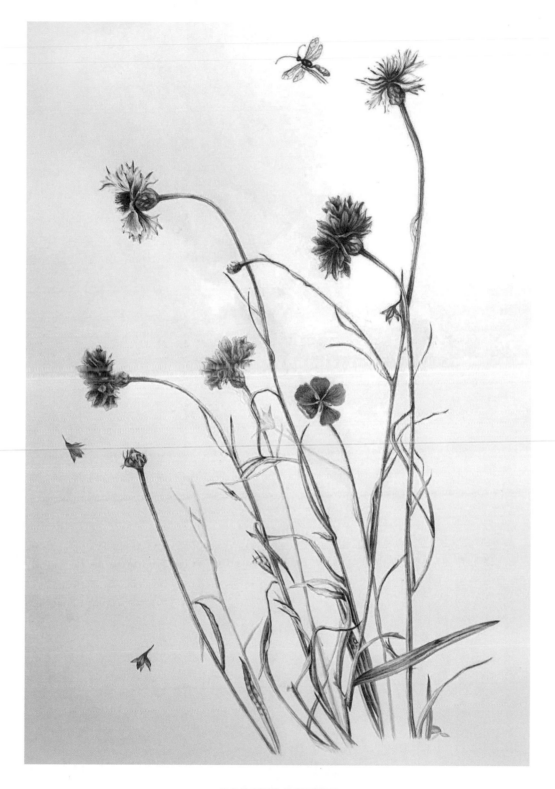

CORNFLOWERS

Watercolour on Arches paper, 57 x 38.5cm

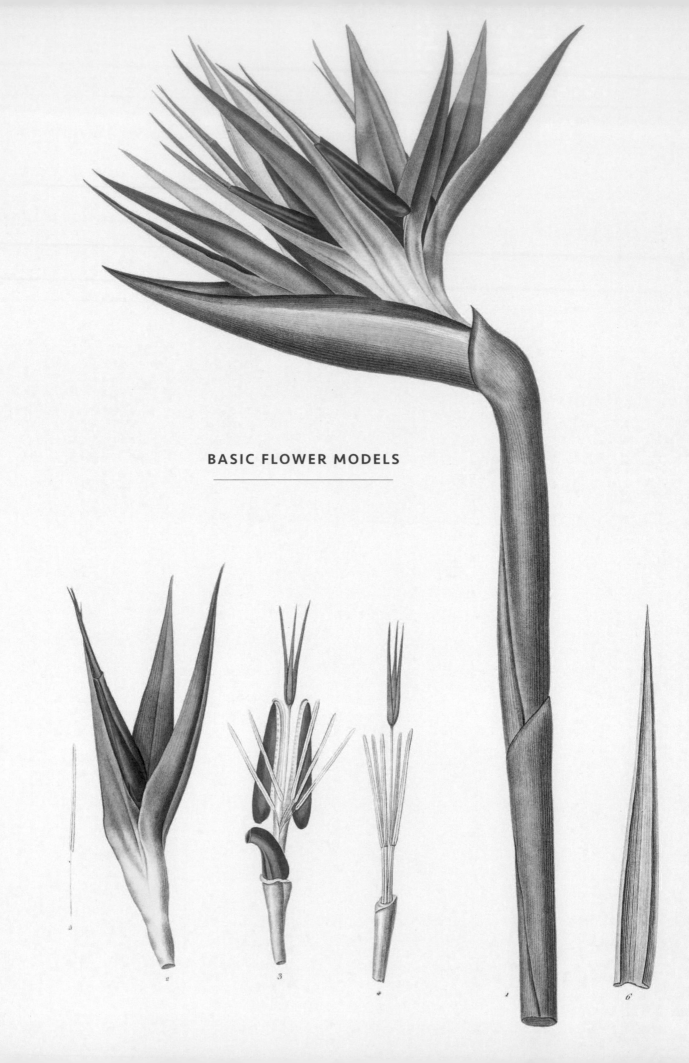

BASIC FLOWER MODELS

HOW TO TRACE A LINE DRAWING OF A FLOWER MODEL AND TRANSFER IT TO WATERCOLOUR PAPER

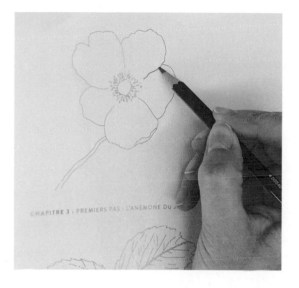

Place the tracing paper over the drawing, and follow the contours of the flower with a soft B (#2) pencil.

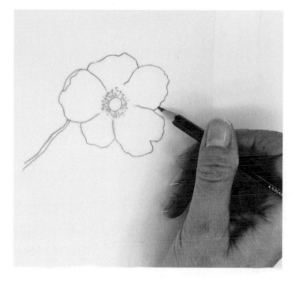

Turn over the tracing paper and go over the contours of the rose again.

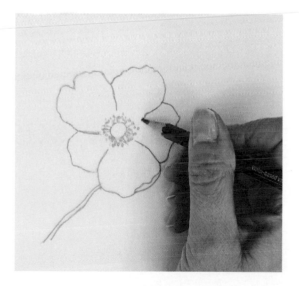

Turn the tracing paper over to the original side and place it on the watercolour paper in the desired position. Then go over the outline of the flower again. Occasionally, lift up a part of the tracing paper to check that the outline is transferring to the watercolour paper.

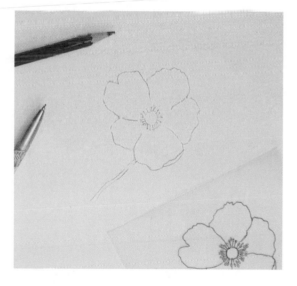

Once the transfer is complete, you can continue creating outlines in the same way. It is a bit time consuming to do it this way, but it is practical because it avoids damaging the watercolour paper which is quite fragile.

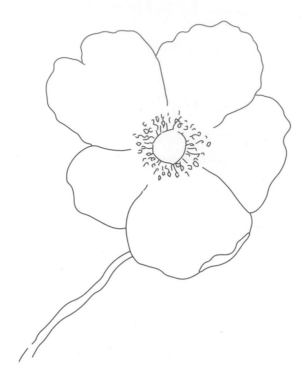

CHAPTER 3: FIRST EXERCISE – A JAPANESE ANEMONE

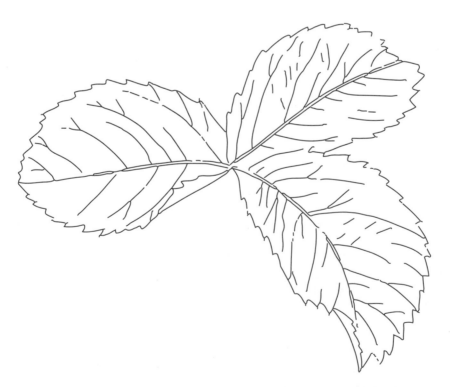

CHAPTER 5: COMPLICATED LEAVES: ROSES

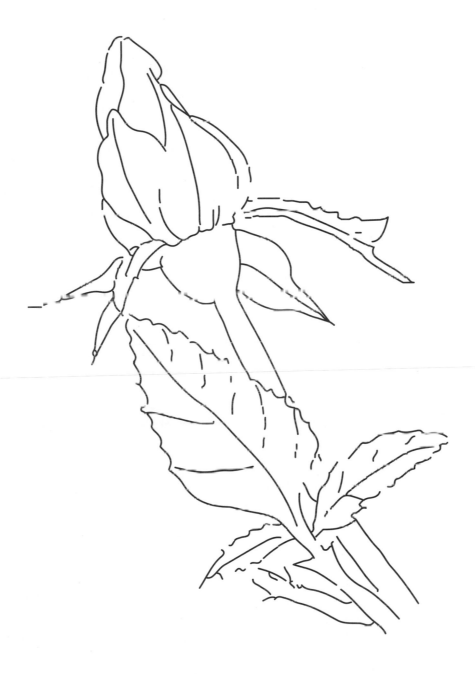

CHAPTER 6: ROSEBUDS

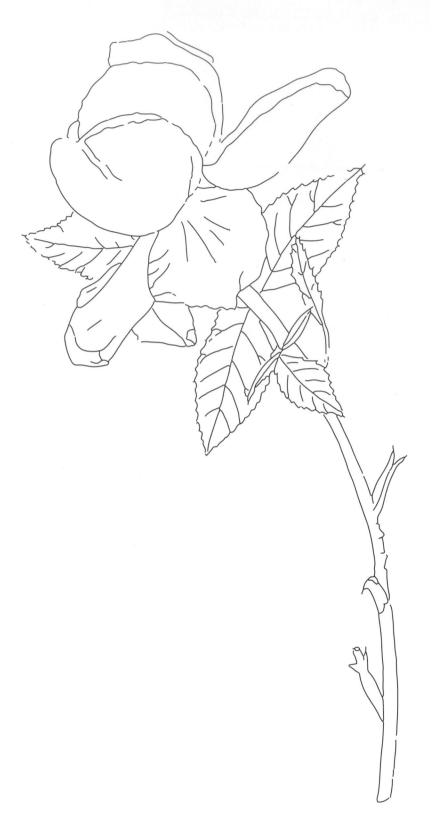

CHAPTER 7: SIMPLE ROSES

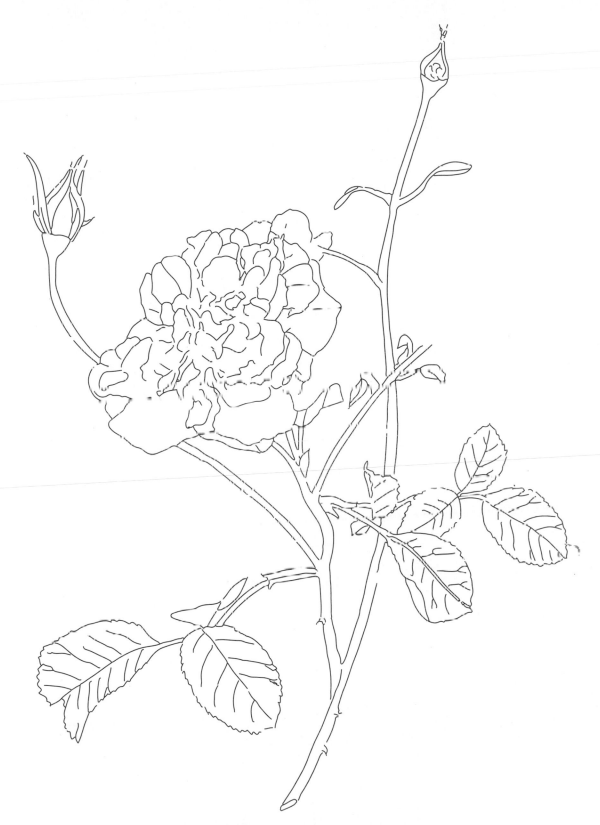

CHAPTER 8: INTRICATE ROSES

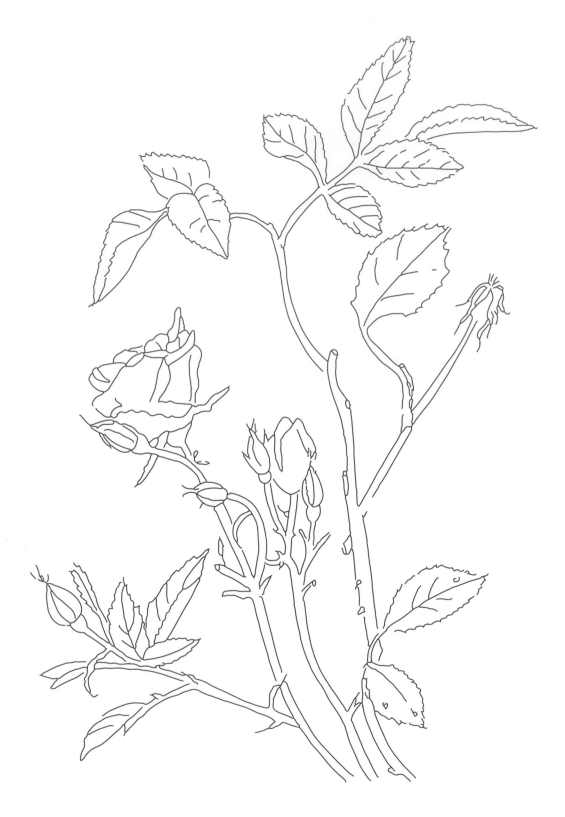

CHAPTER 9: YELLOW ROSES

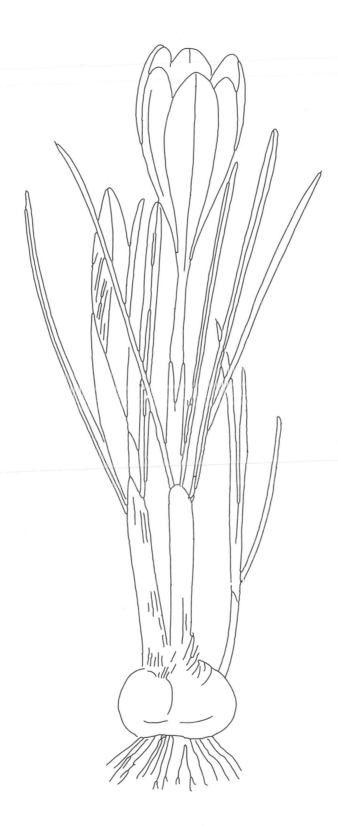

CHAPTER 10: BLUE FLOWERS: CROCUSES

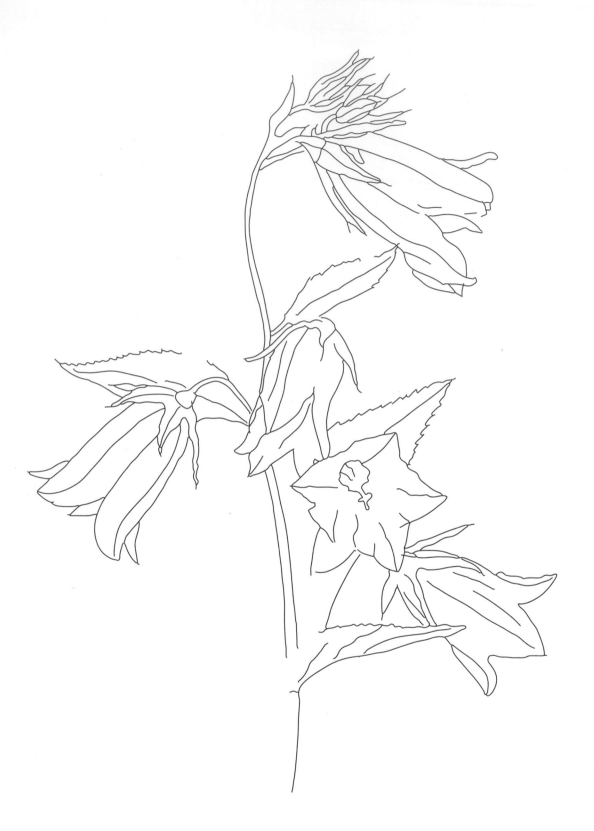

CHAPTER 11: MAUVE FLOWERS: CAMPANULAS

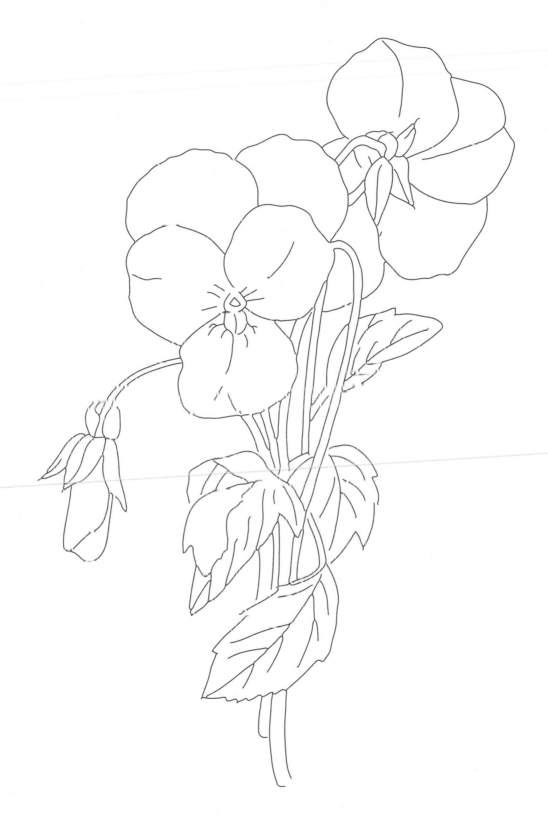

CHAPTER 12: YELLOW AND VIOLET PANSIES

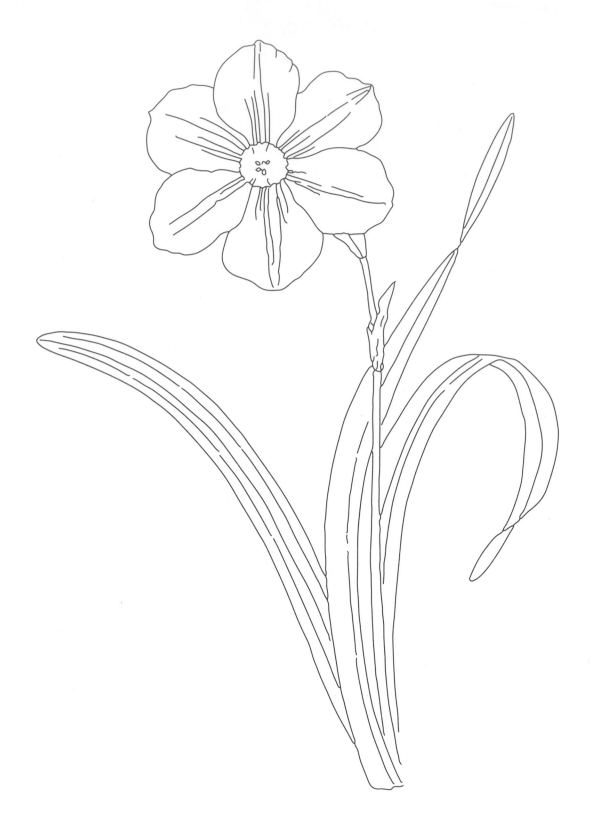

CHAPTER 13: WHITE FLOWERS: NARCISSI

CHAPTER 14: RED FLOWERS: ROSES

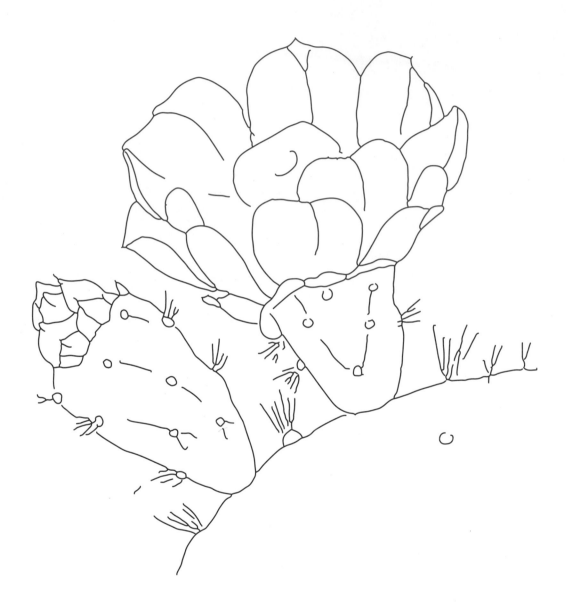

CHAPTER 15: CACTUS FLOWER ON VELLUM

CHAPTER 17: BOUQUETS

AFTERWORD

A love of nature should be your principle guide; watercolour is a means of expression. With a little tenacity and discipline, your work will improve. Patience is the key to success. Surround yourself with plants and create a workspace for your art in your home. Take advantage of winter to copy the works of masters and work from photos you've taken during nice weather.

Let's conclude with some words from Pierre-Joseph Redouté:

'It was by always studying nature with constancy, and the variety of its forms and colours, that I believe I was able to succeed in rendering the tripartite relationship between precision, composition and colour; only together can they bring perfection to botanical iconography.'

Françoise Balsan graduated with a degree in Art History from the École du Louvre and the Sorbonne (Paris IV), and specialised in botanical watercolour.

After first copying oil paintings – in particular, the botanical flower paintings of Ambrosius Bosschaert, Jan Davidsz de Heem and Jan Brueghel the Elder – she switched to watercolour. Balsan considers Nicolas Robert, Claude Aubriet, Maria Sibylla Merian and Pierre-Joseph Redouté to be masters of the genre.

With her academic background, Balsan researched the writings of Redouté's students while studying his techniques. Thanks to her teaching experience, the techniques of early 19th-century watercolour painting have become accessible in this book.

Balsan teaches in Paris and Saint Germain-en-Laye, and holds seminars in botanical watercolour painting in the Perche region of France.

Contact:
francoise _ balsan@hotmail.fr
Visit Françoise's blog:
https://www.aquarelart.org/

— ACKNOWLEDGEMENTS —

This work would not have been possible without the precious help of my daughter, Marie. My sincere thanks to Béatrice Saalburg for her excellent teaching and encouragement; to Christine Asparre for her invaluable advice, and for taking the time to read my original manuscript; to Michel Gasc for his excellent photographs; and to Susan Ries for the translation into English.

Finally, my heartfelt affection for Ray Madec, without whom this book would not have happened; and to my students, who encouraged me to pursue my work on this book.

— BIBLIOGRAPHY —

SOURCES

Bajet, Jules: A Redouté, Paris, 1840

Blunt, Wilfrid, assisted by Stearn, William T.: The Art of Botanical Illustration, Collins, London, 1950.

Delcourt, R.: Pierre Joseph Redouté, botaniste illustrateur (1759–1 1840), 'La fleur dans les arts', Liège, 1950.

Duhamel, Henri-Louis: Traité des arbres et arbustes que l'on cultive en France, par Duhamel. Nouvelle édition, avec des figures, d'après les dessins de P.-J. Redouté, 7 volumes, 1800–1819.

Dumas, Jules: Le Redouté des Dames ou Abrégé élémentaire du dessin des fleurs et fruits, F. Chavant, Paris, 1836

Hamilton, Jill: Redouté's flowers, London, 2001.

Hardouin-Fugier, Elisabeth: The Pupils of Redouté, Leigh-on-sea, 1981.

Huard, Etienne: L'art de peindre sans maître les fleurs à l'aquarelle et de colourier les gravures : petit manuel des arts par M.E. Huard, Paris, 1839

Laissus, Yves: Redouté et les vélins du Muséum national d'Histoire naturelle, Paris, 1980.

Lawalrée, André: Pierre-Joseph Redouté 1759–1840 : la famille, l'œuvre, t. 7, Bruxelles, Crédit Communal, coll. 'Saint-Hubert en Ardenne Art–Histoire–Folklore', 1996.

Léger, Charles: Redouté et son temps, Paris, 1945.

Michel, Marianne Roland: The floral art of Pierre-Joseph Redouté, London, 2002–03.

Pascal, Antoine: L'Aquarelle, ou les fleurs peintes d'après la méthode de M. Redouté, Paris, 1837

Pincemaille, Christophe: Auguste Garnerey, Vues du jardin de Joséphine, Editions des Falaises, Paris, 2018.

Redouté, Pierre-Joseph: Choix des plus belles fleurs et de quelques branches des plus beaux fruits. Dédié à LL. AA. RR. les princesses Louise et Marie d'Orléans, 1827.

Redouté, Pierre-Joseph Les Liliacées, 8 volumes, 1802–1816.

Redouté, Pierre-Joseph Plantes grasses, 2 volumes, 1790

Redouté, Pierre-Joseph Les Roses, 3 volumes, 1817–1824.

Salvi, Claudia: Pierre-Joseph Redouté le Prince des fleurs, Renaissance du Livre, 2001.

Spaendonck, G. van: Fleurs dessinées d'après nature, Bance, Paris

Catalogue de 486 liliacées et de 168 roses peintes par P.-J. Redouté, 1829.

Alphabet Flore. Renfermant 192 dessins, composé des plus belles fleurs, croissant dans toutes les parties du monde/dessiné d'après nature par P. J. Redouté et ses principaux élèves, et lithographié par Chirat. Graveur, 1835.

EXHIBITION CATALOGUES

Musée de la Vie romantique (Paris): Le Pouvoir des fleurs: Pierre-Joseph Redouté (1759–1840), Paris, Paris Musées, 2017.

Muséum national d'Histoire naturelle (Paris): Catalogue de l'exposition du Muséum national d'Histoire naturelle (Paris), Fleurs du Roi, peintures, vélins et parterres du Grand Trianon, Paris, 2013

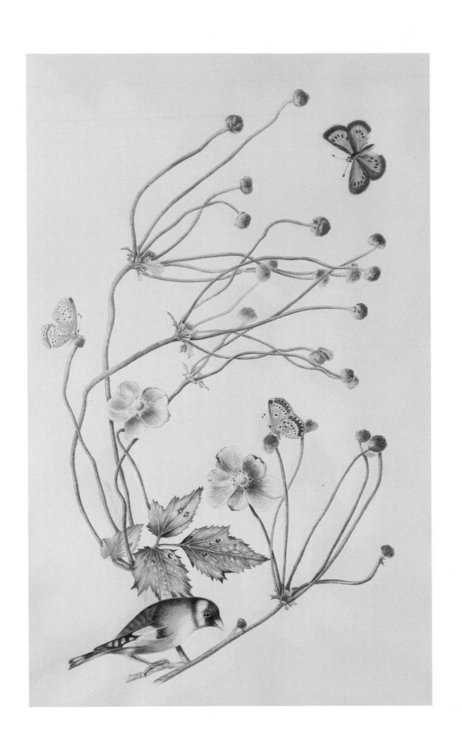